Josephine Meckseper

migros museum für gegenwartskunst Zürich
Blaffer Gallery, the Art Museum of the University of Houston
Ausstellungshalle zeitgenössische Kunst Münster

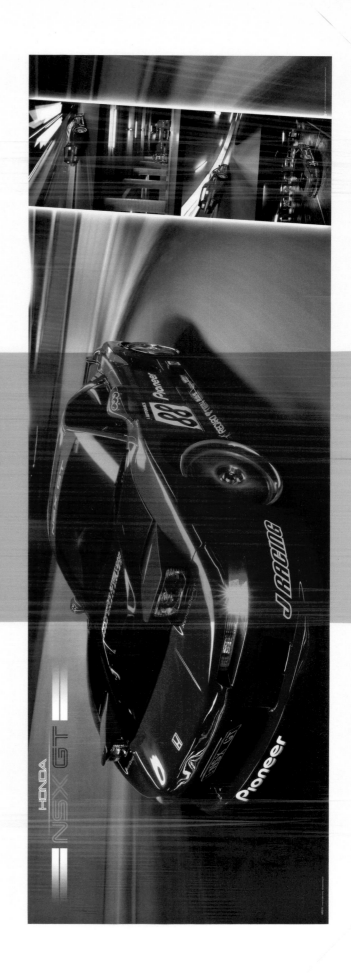

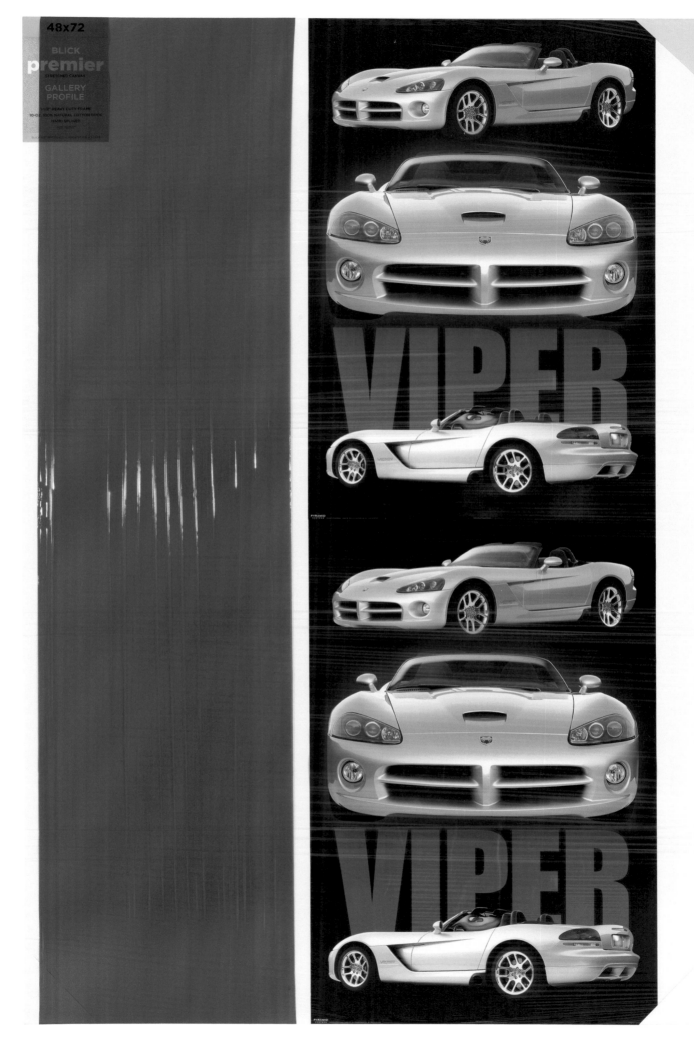

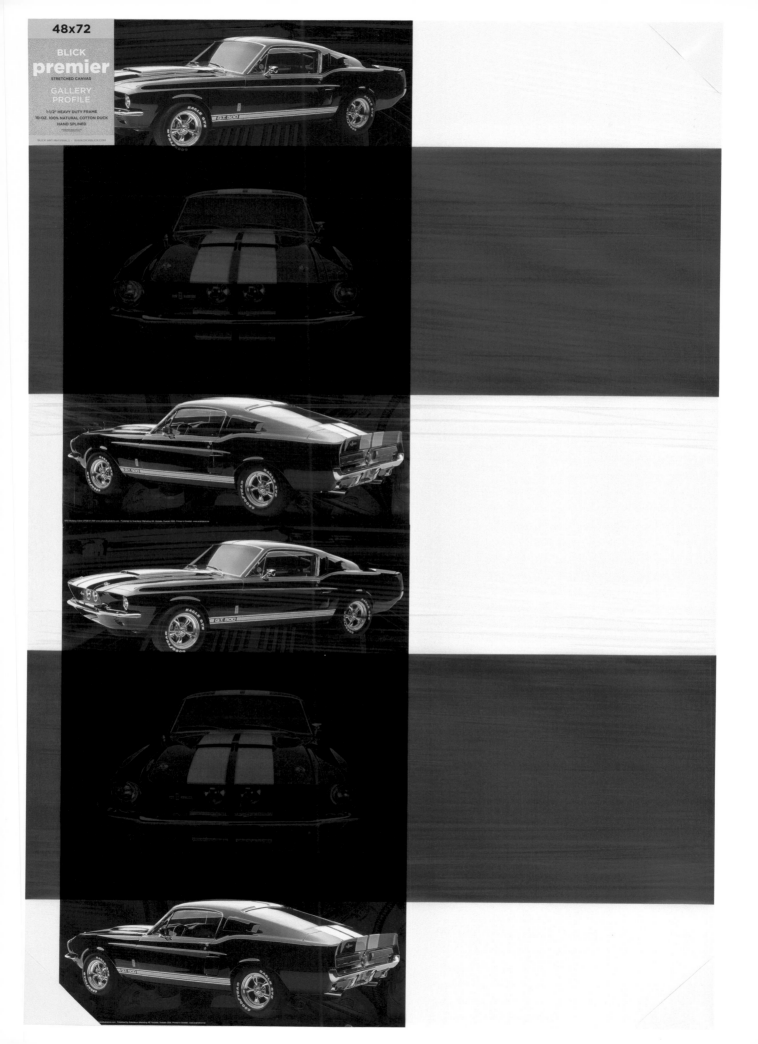

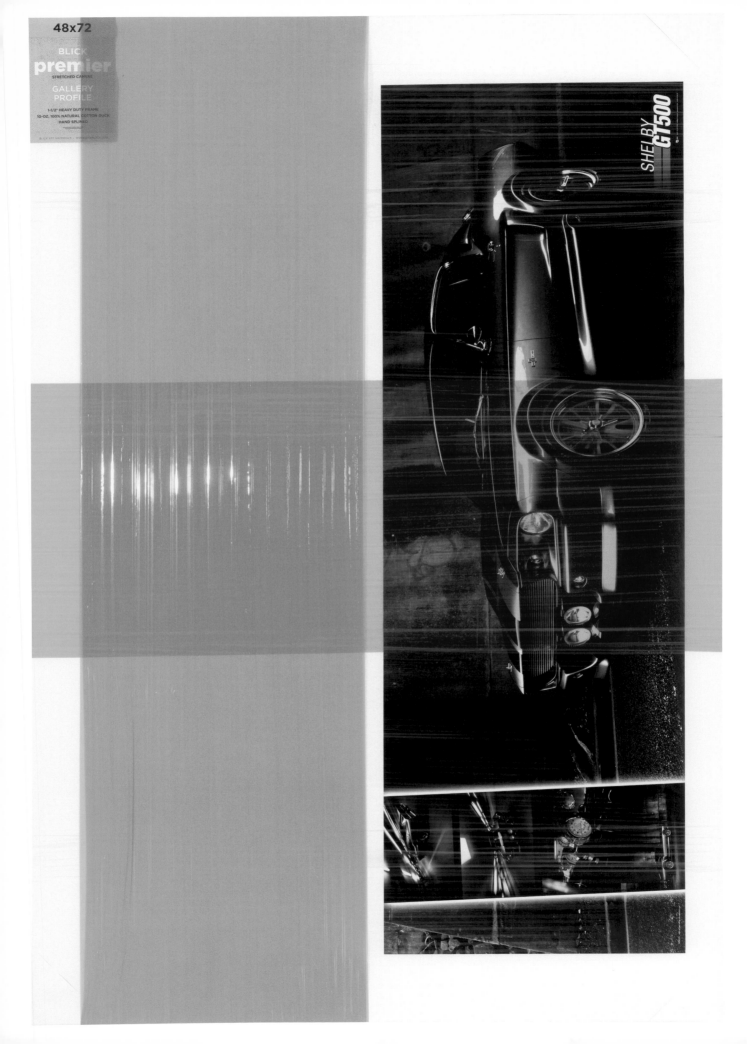

Inhaltsverzeichnis

Rachel Hooper, Gail Kirkpatrick,
Heike Munder
12 Prolog

Heike Munder
15 *Die eleganteste Korruption
zeitgenössischer Kultur*

Rachel Hooper
23 *Nun ... Sturm brich los!*

Sylvère Lotringer
29 *Der grosse Crash*

Table of Contents

Rachel Hooper, Gail Kirkpatrick,
Heike Munder
13 Prologue

Heike Munder
45 *The Most Elegant Corruption
of Contemporary Culture*

Rachel Hooper
51 *Now, Let the Storm Break Loose*

Sylvère Lotringer
57 *CRASHING*

68 Authors' Biographies

69 Biography Josephine Meckseper

71 List of Works

Prolog

Die Ausstellung im migros museum für gegenwartskunst Zürich, der Ausstellungshalle zeitgenössische Kunst Münster und der Blaffer Gallery, The Art Museum of the University of Houston, zeigen zum ersten Mal eine neue Werkgruppe der deutschen Künstlerin Josephine Meckseper. Die Serie ist im Kontext einer Auseinandersetzung mit der Verquickung der Automobil- und Ölindustrie mit dem Irakkrieg entstanden. Die Künstlerin verwandelt Wahrzeichen des industriellen Wirtschaftserfolgs, die den amerikanischen Neoliberalismus repräsentieren, in Symbole für dessen Dekadenz und Verfall. In pointiert zusammengeschnittenen Videoprojektionen bietet Meckseper verschiedene Perspektiven eine Neubeurteilung zeitgenössischer politischer und werbestrategischer Rhetorik an.

Meckseper beschäftigt sich seit Anfang der 1990er Jahre in Installationen, Fotografien und Filmen konzeptionell mit den Wechselwirkungen von Konsum und Politik. Neben Produkten der glitzernden Warenwelt stehen Artefakte eines politischen Aktivismus, wodurch eine irritierende Konstellation herbeigeführt wird: Schaufensterpuppen, die als Exponate einer konsumfreudigen Gesellschaft fungieren, erhalten Demonstrationsparolen auf Pappschildern umgehängt, oder Glamour-Accessoires und Klobürsten werden mit Bildern von Demonstrationen konfrontiert, die Meckseper fotografierte. Die vordergründig absurde Disposition zweier entgegengesetzter Welten in einem scheinbar nahtlosen Display verweist auf die Verschleifung politischer und ästhetischer Prinzipien in den Massenmedien. Meckseper arbeitet mit Symbolen, die ihr wie Metaphern zur Kritik an der spätkapitalistischen Gesellschaft dienen.

Dieses Buch ist das Resultat der ersten gemeinsamen Kooperation der Ausstellungshäuser migros museum für gegenwartskunst, Blaffer Gallery, The Art Museum of the University of Houston, und der Ausstellungshalle zeitgenössische Kunst Münster. Unser besonderer Dank gilt den Leihgebern, allen Beteiligten und Mitwirkenden aus Münster, Houston und Zürich und besonders Josephine Meckseper und ihrem Team. Wir sind auch Arndt & Partner, Berlin/Zurich, der Galerie Reinhard Hauff, Stuttgart und Elizabeth Dee Gallery, New York zum Dank verpflichtet, die wichtige Partner während des Planungsprozesses für unsere Ausstellungen waren.

Rachel Hooper, Gail Kirkpatrick, Heike Munder

Prologue

The exhibitions at the migros museum für gegenwartskunst in Zürich, the Ausstellunghalle zeitgen-össische Kunst Münster (Center of Contemporary Art, Münster) and the Blaffer Gallery, the Art Mu-seum of the University of Houston, are debuting a new group of works by the German artist Josephine Meckseper. The series was made in the context of the complicity of the automobile and oil industries with the war in Iraq. The artist transforms emblems of the industrial economic expansion, representa-tive of American neoliberalism, into symbols of its decadence and downfall. In incisive video projec-tions, Meckseper offers various perspectives from which to consider a reassessment of contemporary political and strategic advertising rhetoric.

In her installations, photography and films since the early 1990s, Meckseper has engaged concep-tually with the interaction of consumerism and politics. Products from the glittering world of com-modities are juxtaposed with artifacts of political activism, forming a disturbing constellation: shop display mannequins that act as emblems of a consumer happy society, cardboard signs hanging off them inscribed with demonstration slogans; or glamorous accessories and toilet brushes confronted with images of demonstrations photographed by Meckseper. The ostensibly absurd juxtaposition of two opposing worlds in an apparently seamless display refers to the blurring of political and aesthetic principles in the mass media. Meckseper works with symbols, which serve as metaphors for a critique of late capitalist society.

This book is the result of the first collaboration between the migros museum für gegenwartskunst, Blaffer Gallery, the Art Museum of the University of Houston and the Ausstellungshalle zeitgenössische Kunst Münster. Our special thanks go to the lenders, to all those participating and working together in Münster, Houston and Zürich, and in particular to Josephine Meckseper and her team. We are also in-debted to Arndt & Partner, Berlin/Zurich, Galerie Reinhard Hauff, Stuttgart and Elizabeth Dee Gallery, New York who have been important partners throughout the planning process of these exhibitions.

Rachel Hooper, Gail Kirkpatrick, Heike Munder

Heike Munder

Die eleganteste Korruption zeitgenössischer Kultur

Noam Chomsky, einer der bedeutendsten kritischen Intellektuellen Nordamerikas und seit dem Vietnamkrieg weltweit als scharfer Kritiker der US-Aussenpolitik bekannt, setzt aus unterschiedlichen Informationen, die er seither unermüdlich sammelt, ein Gesamtbild der amerikanischen Aussen- und Kriegspolitik wie ein Mosaik zusammen. Demnach ist das Ziel der politischen Administration in den USA darin zu sehen, die unangefochtene Hegemonie über Völker und Nationen anzustreben und eine unipolare Welt zu schaffen. Damit einher geht die Vorstellung, dass die Erde wie eine riesige Handelsdrehscheibe von Gütern, Geld und Menschen funktioniere, um wirtschaftliche Interessen der amerikanischen Elite zu befriedigen. Um dieses Ziel zu erreichen und es insbesondere vor breiten Kreisen zu rechtfertigen, fällt den Medien laut Chomsky eine zentrale Rolle zu: In immer neuen Varianten konstruieren sie Terrorszenarien, um eine ständige Bedrohung von aussen zu suggerieren.

Chomsky ist bekannt für seine plakative Darstellung der Verhältnisse. Diese wurde selbst vielfach Gegenstand von Kritik. Doch gerade seine moralisierende Wachsamkeit und die kompromisslose Distanz zur Macht, die er seit über vierzig Jahren hält, machen seine Einschätzungen auch für uns in verschiedener Hinsicht interessant und fruchtbar, um die Arbeiten der Künstlerin Josephine Meckseper und ihre Arbeitsmethodik zu diskutieren Mit den Phänomenen des Hegemonieanspruchs der USA, verbunden mit dem derzeitigen Verfall der amerikanischen Konsumkultur im Zuge einer in ihrer Erscheinungsform beispiellosen wirtschaftlichen Krise sowie einer durch die Medien inszenierten, von Terrorfurcht geprägten Alltagskultur,[1] beschäftigt sich auch Meckseper in einer ganzen Serie neuer Arbeiten, die in den Jahren 2007 und 2009 entstanden sind.

In ihrer Videoarbeit *Mall of America* (2009) untersucht Meckseper das gleichnamige Einkaufszentrum in Minneapolis, die grösste Shoppingmall Nordamerikas. Meckseper ist dabei nicht nur der uneingeschränkten Perversion des amerikanischen Konsums auf der Spur – so befinden sich in dieser Mall unter anderem über 500 Geschäfte, Funparks, Kinos, Nightclubs, Restaurants sowie Hotels –, sondern sie untersucht auch eine der herausragenden Touristenattraktionen Amerikas als Sinnbild des American Way of Life. Darüber hinaus befindet sich im Einkaufszentrum eine aufwendig hergerichtete Militärrekrutierungsstelle, die auf den ersten Blick wie ein Souvenirladen erscheint. Darin werden jungen Männern und Frauen in multimedialer Form Abenteuer versprochen, aber auch Erfahrungen von Solidarität und Teamgeist, sofern sie sich nur bereit zeigen, in die US-Armee einzutreten. Die Mall erscheint als der richtige Ort für eine solche Einrichtung, gilt sie in der Werbung doch als Kommunikationstreffpunkt und Agora der Nation. Die Besucher sollten sich dort entspannt und sicher fühlen und den Eindruck bekommen, dass die Umgebung der Mall eine bessere Realität darstelle als das Alltagsleben. Meckseper koloriert die Filmaufnahmen der Shops und Flaneure mit soften Farbblenden in Rot, Blau und Weiss, den Farben der amerikanischen Flagge. Dadurch wirken die unverfälschten Rekrutierungswerbefilme trotz ihrer Inszeniertheit seltsam «echt». Der filmische Spaziergang durch die Mall wird aufgrund der Farbgebung, der Verlangsamung der Bildspur und des gespenstischen elektronischen Sounds zu einem surreal anmutenden schlechten Traum, der ganz und gar nicht die manipulative Idee eines besseren Lebens bestätigt, sondern die Vorstellung von einer im Verfall begriffenen Gesellschaft.

In ihrer Installation *Ten High* von 2008 nimmt Meckseper sowohl die im gleichen Jahr einsetzende Wirtschaftskrise als auch den aktuellen Zustand der USA während des Wahlkampfs zwischen Barack Obama und John McCain ins Visier. Auf einem glänzenden schwarzen Podest aus Plexiglas mit ebenfalls schwarz glänzender Wandtafel – Farbe und Beschaffenheit sind eine Anspielung auf flüssiges Öl – stehen drei silberne Schaufensterpuppen ohne Kopf. Eine der Puppen trägt ein Schild in den Händen mit der Aufschrift «Going out of business. SALE» – eine direkte Referenz auf die sich in den USA abzeichnende schwere Rezession. Eine andere trägt eine Krawatte mit christlichen Symbolen als Sinnbild für die Repräsentanten der erzkonservativen, bibeltreuen Bevölkerung, die gerne gemeinsam mit den Waffenlobbyisten auftreten. Vor den Füssen dieser Puppe steht ein auf Aluminium aufgezogenes Plakat einer Mustang-Autokampagne angelehnt. Die einarmige dritte Puppe wiederum trägt ein T-Shirt mit dem Aufdruck «If You Love Your Freedom, Thank a Vet». An sie gelehnt, ist ein zerschossen wirkender Spiegel platziert. Vor der Puppe sieht man eine Gehhilfe – mit einer Whiskeyflasche, einem Aschenbecher und einer Bibel ausgestattet, lässt sie sich als ein provokanter Kommentar zur neuesten Generation der US-Kriegsveteranen verstehen. Mecksepers glänzende Displays mutieren schnell zu einem bissigen Kommentar über die Kehrseite der Bush-Politik: die verfallene Wirtschaft, den christlichen Fanatismus, die Kriegsopfer und die

[1] Das Zusammenspiel von Kulturindustrie und Krieg interessiert Tom Holert und Mark Terkessidis, die in ihrem vielfach kritisierten, aber anregenden Buch *Entsichert* (2002) diesem Phänomen nachgehen. Anhand von ehemaligen Kriegsschauplätzen von Vietnam bis zum Balkan, den Anschlägen vom 11. September und Filmen wie *Wall Street* (1987) oder *Boiler Room* (2000) versuchen sie, die wie selbstverständlich eingesetzte kriegerische Bildsprache der Berichterstattung zu analysieren.

oftmals in bitterer Armut lebenden Kriegsveteranen. Die tatsächlichen Lebensumstände der Veteranen stehen im frappanten Gegensatz zur Glorifizierung durch Medien und Regierung, insbesondere im Wahlkampf von McCain.

Noch konkreter nimmt sich Meckseper dem Veteranenthema in *Thank a Vet* (2008) an. In der Arbeit steht nicht der Glanz eines sublimierten Konsumprodukts im Vordergrund, sondern das Augenmerk richtet sich auf verschiedene Dinge des Alltags, die auf einem Spiegelpodest präsentiert sind: ein Ölkanister, eine Klobürste mit einem dazugehörigen WC-Teppich, Strumpfbeine und ein kopf- und armloser Torso in einem «Thank a Vet»-T-Shirt bilden das Porträt eines «wahren Bewahrers» der US-Freiheit. Ähnlich wie in der Arbeit *Ten High* strebt die Künstlerin eine Entmystifizierung politisch aufgeladener Embleme an. In ebenso frappierender Weise nimmt Meckseper in der Arbeit *Blackwater, No Country for Old Men* (2008) Bezug auf die Verquickung von privatwirtschaftlichen und militärischen Interessen. Hier geht es um die Rolle der US-amerikanischen Sicherheitsfirma Blackwater, die als privatwirtschaftlich agierende Unternehmung in den Irakkrieg verwickelt ist, der auf offizieller internationaler Ebene geführt wird. Das Firmenlogo von Blackwater – eine Tatze – bildet Meckseper auf einer Spiegeloberfläche ab, zusammen mit dem titelgebenden Schriftzug «No Country For Old Men», der auf den gleichnamigen Film der Coen-Brüder von 2007 hinweist, einem Abbild John McCains und einer Gehhilfe. Blackwater rekrutiert und entsendet Söldner im Auftrag der Firma Halliburton in den Irak, eines Konzerns unter der ehemaligen Leitung des später amtierenden US-Vizepräsidenten Dick Cheney. An sich müsste die Firma bzw. müssten die Söldner für die Morde an der Zivilbevölkerung zur Rechenschaft gezogen werden. Das Justizministerium teilte jedoch mit, dass es keine formale Handhabe gebe, um Blackwater für die Verbrechen zu verurteilen – weder nach militärischem noch nach zivilem Recht. Die USA haben dafür gesorgt, dass es den irakischen Behörden nicht möglich ist, sie als Mörder im eigenen Land anzuklagen. Die Bush-Administration wiederum weigerte sich, das internationale Recht anzuerkennen. Zudem fliesst eine grosse Menge an Geld, die Blackwater rechtsgerichteten Kreisen der Republikaner und christlichen Zirkeln als Spenden zukommen lässt. Auf diese Weise entstand ein eigenes System von Kriegsprofiteuren – eines der dunkelsten Kapitel der Bush-Administration. Aber auch der republikanische Kandidat McCain machte im Präsidentschaftswahlkampf als Lobbyist von Blackwater negative Schlagzeilen, als er seine Wahlkampfkasse mit Geldern aus dieser Quelle aufzubessern versuchte. Dem Thema der Altherren-Kriegsveteranen-Lobby wurde damit erneut Aktualität verliehen. Meckseper erzählt diese Zusammenhänge nicht in einem narrativen Sinn. Sie erinnert vielmehr an die politischen Verstrickungen und Wirren, indem sie die einzelnen Bilder auf der Spiegelfläche aneinanderreiht.

Es stellt sich die Frage, wie lange solche Metaphern, die auf eine spezifische historische Situation referieren, für Betrachter lesbar bleiben. Gleiches gilt für Chomskys Schriften. Die unmittelbare Zeitbezogenheit macht ihn wie Meckseper zu wichtigen Chronisten angesichts der allgemeinen Tendenz zur Verzerrung und Verdrängung von gesellschaftspolitischen Tatsachen. Neben der formalen Differenz wagt Chomsky im Unterschied zu Meckseper auch immer wieder Prognosen. Solche Prognosen besitzen natürlich im Nachhinein nicht mehr die Bedeutung, die sie zur Zeit ihrer Formulierung hatten, als sie die Ängste der Gesellschaft in jenem Moment aufgriffen. Auch Meckseper nimmt die Ängste der Gesellschaft wie ein Zerrspiegel auf, doch arbeitet sie im Gegensatz zu Chomsky von einer konzeptuellen Idee aus und nicht von einer ideologischen Warte. Bei ihren hier besprochenen neuesten Arbeiten allerdings interessiert die Künstlerin, ähnlich wie Chomsky, die Auseinandersetzung mit der Repräsentation und der Rhetorik von Propaganda und Machtausübung. Sie sammelt in ihren Arbeiten in fast ethnologisch anmutender Weise Symptome zum Zustand unserer Gesellschaft und setzt diese in unterschiedliche Zusammenhänge, die abhängig sind vom Kontext und der Erinnerung an das Geschehen zum betrachteten Zeitpunkt. Wenn Meckseper als Chronistin politischer Zeitphänomene gegen das Vergessen und die Verdrängung arbeitet, bleibt ihr Werk von der Erinnerung an die historischen Umstände

bestimmt, vielmehr aber ist ihre Arbeitsweise ein Aufruf an die Gesellschaft zur aktiven Konfrontation und Hinterfragung.

Dies gilt auch für die jüngsten Arbeiten der Künstlerin, in denen sie die im nationalen Interesse der USA legitimierten Kriege in strategisch wichtigen Ländern zum Anlass nimmt und dabei das Wertesystem der amerikanischen Gesellschaft befragt. Die lebensgrossen Ölpumpen *Untitled (Oil Rig No. 1)* (2009) und *Untitled (Oil Rig No. 2)* (2009) isoliert Meckseper aus ihrem ursprünglichen Kontext, indem sie diese Symbole der US-amerikanischen Wirtschaftsgeschichte in den Ausstellungsraum transferiert. Es ist das Öl, auf dem ein wichtiger Teil der ökonomischen Erfolgsgeschichte der USA basiert. Den Ölpumpen als Sinnbild für industrielle Kraft, automobilen Fortschritt, Freiheit und Unabhängigkeit stellt sie die Replik eines Bunkers, *Untitled (Bunker)* (2009), aus dem Zweiten Weltkrieg gegenüber, in Anlehnung an einen von Paul Virilio fotografierten Bunker, beschrieben in dessen Buch *Bunker archéologie* (1975). Meckseper ist daran interessiert, in diesen neuen Arbeiten Verbindungen herzustellen zwischen den US-amerikanischen Interessen am Rohstoff Öl, der immensen Abhängigkeit der Automobilindustrie von diesem fossilen Energieträger und den im Nahen Osten geführten Kriegen. Am eindrücklichsten geschieht dies durch das von Meckseper zusammengeschnittene Filmmaterial aus Fernsehwerbespots für Autofirmen, vertont mit einem nachhaltig durchdringenden Industrial-Noise-Song von Boyd Rice mit der Textzeile «Do you want – total war?»: Im Video *0% Down* (2008) dekonstruiert sie die suggestive Bildsprache der Werbestrategen. Autos werden in der Wüste von Militärjets eskortiert, und Flugzeugdüsen stählen die Karosserie. Vorwärtsdrang, Unverwundbarkeit und militärische Faszination stehen für eine kämpferische und willensstarke Nation – eine gewaltaffirmierende Ästhetik eines Krieg führenden Landes. Die Autowerbungen beschreiben die Fantasie und beschwören die Suggestion von Potenz und Macht über andere als einen Anspruch, der normalerweise nur einer hegemonialen Supermacht zusteht. In der neokonservativen amerikanischen Ideologie beansprucht jeder Einzelne diese Macht. Eine Geisteshaltung, die sich in den gezeigten Werbesequenzen durch eine dem Betrachter suggerierte Entscheidungsfreiheit bei der Wahl des richtigen Autos manifestiert. Diese Arbeit synthetisiert eine Serie von Mecksepers Werken und markiert in der skizzierten Verknüpfung ökonomischer, politischer und militärischer Kontexte einen Kulminationspunkt ihres Schaffens.

Nimmt man nun Chomskys Kritik ernst, lassen sich Mecksepers Arbeiten wie *0% Down* als eine überspitzte Auseinandersetzung mit dem Phänomen interpretieren, das Chomsky Anfang 2000 als «Media Control» bezeichnete.[2] Damit spricht er eine subtile Form der Gleichschaltung durch die amerikanischen Medien an, die sich über die Etablierung bestimmter Ideen im kollektiven Bewusstsein vollzieht. Nach Chomsky haben wir es insofern mit einer Diktatur der Medien zu tun, da selbst in freien Demokratien die Bevölkerung einer massiven Manipulation durch dieselben ausgesetzt ist. Einer seiner Hauptanklagepunkte gegenüber den Medien ist deren Verbreitung von Werbebotschaften, welche er als eine «transnationale Firmentyrannei»[3] bezeichnet. Denn die Hauptfunktion der Medien habe sich darauf reduziert, den Werbern ein unkritisches Publikum zu verkaufen: «Sie [die Werber] bezahlen nicht für eine Diskussion, die die Leute ermutigt, an der Demokratie teilzunehmen und die Macht der Firmen anzugreifen.»[4] In einem Interview lobt Mecksepers Künstlerkollege Liam Gillick die Arbeit *0% Down* als «eine der elegantesten und schnittigsten Korruptionen zeitgenössischer Kultur, die ich je gesehen habe» («It was one of the most elegant and cutting corruptions of contemporary culture I have seen»).[5] Gillick greift in seinem Kommentar Chomskys Idee der Medienkontrolle auf, wonach wir es bei der Überflutung der Informationskanäle mit spezifischen Inhalten mit einer geradezu perfekten Methode der Manipulation durch die Medien zu tun haben. Die ständige Wiederholung

[2] Siehe Noam Chomsky: *Media Control: Wie die Medien uns manipulieren,* Hamburg 2003.
[3] Noam Chomsky im Interview «Diktatur der Medien», in der Humanistischen Zeitschrift *Humanscape,* Indien. In: http://squat.net/gib/infowar/diktatur-der-medien.html.
[4] Noam Chomsky (wie Anm. 3).
[5] Liam Gillick im Interview mit Josephine Meckseper, www.interviewmagazine.com/art/josephine-meckseper.

von Bild- und Textinhalten macht Letztere zu etablierten Wahrheiten, die kaum noch hinterfragt werden.[6] Die Suggestivkraft der Werbung erweist sich in dieser Hinsicht dem Einfluss der Nachrichtensendungen überlegen. In seinem Modell erläutert Chomsky, wie die Massenmedien im kapitalistischen Umfeld die Berichterstattung gestalten, damit die Interessen der Regierung und der oberen Gesellschaftsschichten gewahrt bleiben. Denn es kommt Chomsky zufolge nicht so sehr darauf an, eine breite Öffentlichkeit für sich zu gewinnen, sondern vielmehr, die Meinungsführer zu erreichen. Entsprechend zahlt sich eine tendenziell regierungsfreundliche Berichterstattung längerfristig sowohl für die Wirtschaft als auch für die Medienkonzerne aus. Man könnte dies auch als gezielte Lenkung von öffentlichen Diskursen bezeichnen, denn die Auseinandersetzung wird nicht grundsätzlich untersagt, sondern auf subtile Art kontrolliert.[7]

Derzeit jedoch droht die Wirtschaftskrise einen der wichtigsten Industriezweige der USA einzuholen: Viele traditionsreiche Automobilfirmen stehen vor ihrem Ende. Die Werbung verkommt zur Farce. Sie unterstreicht in Wirklichkeit nur noch den Niedergang eines Imperiums. Darauf spielt die Arbeit *Fall of the Empire* (2008) an, in der Meckseper den Verfall in einer abgedunkelten Schaufenstervitrine unter anderem mit einem Werbeplakat für das Automodell Hummer, einem WC-Teppich mit der Skulptur eines silbernen Engels darauf und dem in Cellophan eingewickelten Kopf einer Schaufensterpuppe beschreibt. Der auf den Niedergang des Römischen Reichs verweisende Werktitel deutet die zunehmende Degeneration der westlichen Konsumkultur an. Auch die ursprünglich Kauflust auslösenden Motive der Autowerbung, die Meckseper in einer Serie anderer Arbeiten auf Leinwände aufklebt, führen nun nur noch ein abgeschiedenes Dasein. Die Collagen verarbeiten vorgefundene Werbeplakate für prestigeträchtige Autotypen wie Dodge Viper, Honda NSX GT oder Ford Mustang. Die Leinwände sind mit transparenter und rosafarbener Verpackungsfolie eingeschlagen und sehen aus, als kämen sie direkt aus dem Versand. Nichts mehr ist manuell produziert, weder die Leinwände noch die Verpackung; es handelt sich um Kunst als Industrieware. Ein ähnliches Verfahren nimmt Meckseper in *Negative Horizon* (2008) auf. Dort führt sie mit einem verspiegelten Podest und sechs hochpolierten Chromfelgen die Absurdität des Fetischcharakters eines Displays vor Augen. Die Felgen werden zum Statussymbol für einen gesellschaftlichen Mehrwert und verlieren damit ihren ursprünglichen Gebrauchscharakter.

Der Rückgriff auf Chomskys Theorien im Rahmen einer Diskussion der politisch aufgeladenen Arbeiten Mecksepers liegt nahe. Denn Chomsky war lange Jahre einer der meistzitierten Intellektuellen zu politischen Fragen, ein respektierter Gegner der Globalisierung in ihrer vorherrschenden Form und ein Vordenker dieser Protestbewegung. Meckseper wie Chomsky polarisieren, indem sie eine einfache Bild- beziehungsweise Wortsprache benutzen, politische Reizthemen aufnehmen und sehr präzise die aktuellen Geschehnisse kommentieren. Chomskys Sympathien für den Anarchosyndikalismus, der in Europa seinen Höhepunkt zwischen 1880 und 1930 erlebte, lässt die Radikalität vieler seiner Äusserungen verstehen. Hauptziel der Bewegung war die revolutionäre Überwindung des Staates und der kapitalistischen Gesellschaft, woraus eine klassen- und staatenlose Kollektivordnung entstehen sollte. Obwohl von einem Anarchosympathisanten wie Chomsky Radikalität erwartet wird, fungiert er als Sprachrohr einer grossen Anzahl kritischer US-Bürger. Seine Haltung wurzelt unverkennbar in der ideologischen Dogmatik, die sich in der Zeit des Kalten Krieges herausbildete. Zum Beispiel wenn er die USA als terroristischen Staat verurteilt, um deren Vorgehen gegen den Irak oder Afghanistan zu geisseln, ist ihm durchaus auch Schwarzweissmalerei zum Vorwurf zu machen. Seine Argumentation ruft Kritiker auf den Plan, wird andererseits aber auch als ein notwendiges Korrektiv der staatlichen Macht begrüsst.

[6] Noam Chomsky (wie Anm. 2), S. 115.
[7] Siehe Noam Chomsky: *Profit Over People. Neoliberalismus und globale Weltordnung*, Hamburg/Wien 2000.

Meckseper ist mit der dogmatischen Politik der 1960er und 1970er Jahre sehr vertraut, wuchs sie doch in einer politisch aktiven Umgebung auf, mit der sie sympathisierte. Für sie sind plakative Darstellungen oder Überspitzungen Mittel, um Abstand zu Tatsachen zu bewahren. Ihre schwarzweissen Wandbilder *Untitled (Black and White Wall)* und *Untitled (American Flag)* von 2008, in denen sie die US-amerikanische Flagge verfremdet, betrachtet Meckseper als Sinnbild für das Schwarzweissdenken und die simplifizierten Feindbilder der USA. Ebenso benutzt die Künstlerin Vitrinen und erhöhte Plattformen nicht nur als Semantik von Kaufhaus-Displaytechniken, sondern auch wie zum Beispiel in *Ten High* (2008) und *Thank a Vet* (2008), um Distanz zu einem Thema zu erzeugen. Ihre ästhetische Methodik lässt sich am besten anhand einer sehr schlichten Arbeit wie *President's Day* (2007) beschreiben: Hier untersucht Meckseper das Organisationsprinzip von Zeitschriftenlayouts am Beispiel der Anordnung von Werbeseiten und redaktionellen Texten in Magazinen. In der Arbeit exemplifiziert die Künstlerin dieses Verhältnis durch die Aufteilung der schwarz gehaltenen Leinwand in unterschiedlich grosse Felder, die durch weisse Streifen voneinander abgegrenzt sind. Die Abstraktion wirkt wie ein konstruktivistisches klassisches Gemälde und dient Meckseper zur Neutralisation von Gegenüberstellungen unterschiedlicher Symbolwelten in den Medien – in Zeitungen wie der *New York Times* etwa finden sich Artikel über die Opfer im Irak direkt neben der Werbung für Luxusartikel. Doch Meckseper interessiert nicht die Gleichmachung von Themen in der medialen Berichterstattung, sondern die Bandbreite der kapitalistischen Symptome im Allgemeinen und deren unhinterfragte gesellschaftliche Akzeptanz. Diese Herangehensweise prägt die Arbeit der Künstlerin seit den 1990er Jahren, als sie ein Fanzine mit dem Namen *FAT* herausgab.

Für Meckseper ist ein weiteres wichtiges gesellschaftliches Symptom das Thema der Meinungsfreiheit, die in den Jahren unter George W. Bush und speziell seit dem 11. September 2001 durch die Zensur stark eingeschränkt war. Mit ihrem Video *March for Peace, Justice and Democracy, 04/29/06, New York City* (2007) dokumentierte sie 2007 eine der wenigen erlaubten Demonstrationen und deren Protestplakate in New York. Demonstrationen erhielten oft keine Genehmigung, selbst Zeitungen wie die *New York Times* übten keine Kritik am Kriegsgeschehen im Irak oder Afghanistan. Die Vertonung des Videos erinnert an eine Gehirnwäsche mit der immer gleichen monotonen Aufforderung: «Du sollst nichts hören – Du sollst nichts sehen – Du sollst nichts denken – Du sollst nichts sein».

Symbole des politischen Widerstands, wie Protestplakate oder Mecksepers Fotografien von Demonstrationen, vermengen sich in ihren Arrangements mit leicht austauschbaren Konsumprodukten. Die Schaufensterinstallation *Verbraucherzentrale* (2007) stellt Fotografien von Demonstrationen in den USA und in Deutschland einander gegenüber, um die politische Kultur beider Länder miteinander zu vergleichen. Ausserdem befinden sich in der Vitrine mehrere Objekte des täglichen Konsums, die stellvertretend für Gegenstände stehen, die von der Verbraucherzentrale getestet werden. Meckseper orientiert sich nicht nur in den beiden zuletzt angesprochenen Arbeiten an Chomskys Ziel, in der Tradition des Anarchosyndikalismus die Voraussetzungen der Selbstorganisation für das Individuum herzustellen. Dazu zählen Eigeninitiative und kritische Distanz zum Geschehen. Es bedarf folglich eines souveränen Umgangs mit den Medien sowie mit den Symbolen und Metaphern unserer Zeit. Publizierte Informationen und subjektive Eindrücke sind gleichermassen zu hinterfragen. Es ist weithin bekannt, dass Medieninhalte einen massiven Einfluss auf unsere Alltagswahrnehmung haben. Diesen Einfluss zu brechen, ist das Anliegen von Meckseper. Chomskys vielleicht bekannteste Äusserung, die einem Interview entstammt, ist hier wegweisend: «Ein Intellektueller zu sein, ist eine Berufung für jedermann: Es bedeutet, den eigenen Verstand zu gebrauchen, um Angelegenheiten voranzubringen, die für die Menschheit wichtig sind.»[8]

[8] Zu Chomskys 80. Geburtstag erschien eine Sammlung politischer Essays mit dem Titel *Die Verantwortlichkeit der Intellektuellen.*

Rachel Hooper

Nun ... Sturm brich los!

Seit der Ankündigung der Regierung Bush, im Irak mit militärischen Mitteln einzugreifen, hat Josephine Meckseper die massiven Proteste dokumentiert, die dieser Plan in der internationalen Öffentlichkeit ausgelöst hat. Mit ihrer Fotoserie *Berlin Demonstration* (2002) und ihren bald darauf – meist im 16-mm- und im Super-8-Format – gedrehten Filmen, etwa *Rest in Peace* (2004) und *March for Peace, Justice and Democracy, 04/29/06, New York City* (2007), hat sie sich als Beobachterin des weltweiten Strassenprotests positioniert. Die Filme erinnern an die Dokumentationen der Proteste gegen den Vietnamkrieg und üben Kritik an «der Beliebigkeit und dem Unterhaltungscharakter von Nachrichtenberichten».[1] Während Meckseper ihre subversive Kritik an der Darstellung politischer Vorgänge im öffentlichen Raum früher vor allem mit dokumentarischen Mitteln und einer gewissen analytischen Distanz vorgebracht hat, addressiert sie die Kommerzialisierung der Politik seit dem Irakkrieg sehr viel direkter. Bei ihrem Video *0% Down* (2008) handelt es sich um eine Montage diverser Auto-Werbespots, die Anfang 2008 in den US-Medien zu sehen waren. Diese Bilder hat die Künstlerin mit dem – 1997 von dem Industrie-Musiker Boyd Rice unter dem Pseudonym NON eingespielten – Song *Total War* unterlegt. Liam Gillick hat die Videoarbeit sehr treffend als «invertierte Propaganda» bezeichnet,[2] da es Meckseper in dem Film vor allem darauf ankomme, das in den vordergründig ansprechenden TV-Spots angelegte Gewaltpotenzial sichtbar zu machen.

[1] «Josephine Meckseper im Gespräch mit Simone Schimpf», in: *Josephine Meckseper,* hg. v. Marion Ackermann, Ostfildern 2007, S. 24.
[2] Liam Gillick, «Josephine Meckseper», in: *Andy Warhol's Interview,* November 2008, S. 49 f.

Josephine Meckseper lässt sich in ihrem Schaffen vom marxistischen Gedanken leiten, dass sich die ungerechten gesellschaftlichen Machtverhältnisse im Kapitalismus bis in die Erscheinungsform kommerzieller Produkte hinein abbilden. «Meine Arbeit basiert grundsätzlich auf einer Kapitalismuskritik. [Dabei sind meine Werke] nur das Vokabular und verkörpern eine Form der Warenrepräsentation», hat sie einmal erklärt.[3] Diese Aussage erinnert an Jean Baudrillard, der geschrieben hat: «Die Kunst (das Kunstwerk), die in der Epoche der Moderne mit der Herausforderung der Ware konfrontiert wird, sucht ihr Heil nicht in einer kritischen Ablehnung …, sondern indem sie über die formelle und fetischisierte Abstraktion der Ware … hinausgeht – indem sie noch mehr zur Ware wird als die Ware …»[4]

In der Videoarbeit *0% Down* ging Meckseper sogar noch weiter. Bei diesem Video handelt es sich nicht nur um eine «Form der Warenrepräsentation» – es macht zugleich sichtbar, wodurch die Warenform charakterisiert ist. Im Eröffnungskapitel von *Das Kapital* (1867) stellt Karl Marx unter der Überschrift «Der Fetischcharakter der Ware und sein Geheimnis» fest, dass Marktprodukte nicht nur Gebrauchsgegenstände sind, sondern ausserdem einen Wert besitzen – dass «der Wert … jedes Arbeitsprodukts in eine gesellschaftliche Hieroglyphe [verwandelt wird] …, denn die Bestimmung der Gebrauchsgegenstände als Werte ist [ein] gesellschaftliches Produkt so gut wie die Sprache.»[5] Marxistisch gesprochen, verfolgt die Werbung also das Ziel, Produkte so mit impliziten Bedeutungen und Verweisen auszustatten, dass diese auf mysteriöse Weise in der Ware aufgehen. Der Fetischcharakter der Ware besteht in der Identifikation der Ware mit ihrem Assoziationswert. Das Design eines Produkts reflektiert die Werte, die dem betreffenden Produkt zugeschrieben werden, verschleiert jedoch die für den Herstellungsprozess konstitutiven Machtverhältnisse.[6] In ihren Auto-Werbespots wendet Meckseper den Fetischcharakter des Automobils gegen dieses selbst.[7] Die Montage nimmt den Betrachter auf den ersten Blick durch die glatte Perfektion der Darstellung für sich ein, doch dann zeigt sich, dass der Wert, den die Werbung den in ihren TV-Spots angepriesenen Automobilen zuweist, lediglich auf Täuschung beruht.

Zu dem Zeitpunkt als *0% Down* debütierte, waren die im Video gezeigten Auto-Werbespots noch im Fernsehen zu sehen – umso schockierender wirkte ihre Demaskierung durch die Künstlerin. Die Original-Werbespots sollten uns nicht nur zum Kauf dieser Autos und Geländefahrzeuge bewegen, sondern uns ausserdem dazu bringen, uns mit alledem zu identifizieren, wofür diese Fahrzeuge stehen: Tempo, Kraft, Luxus und einen aggressiven Entdeckerdrang. Da Meckseper auf die Farbe und den Ton der Originalspots verzichtete, wirken die Werbebilder in ihrem Video umso drastischer. Auf jedem der Bilder ist zu sehen, wie der Fahrer angesichts einer drohenden Gefahr spielend die Kontrolle behält – Autos, die von ihrem «Piloten» mühelos durch bedrohliche Landschaften gesteuert werden, während am Himmel elegant ein paar Jets vorbeiziehen.

Das Video beginnt mit einem tiefen synkopierten Wummern. Zu diesem Beat gesellt sich bald die Endlosschleife einer schrillen Sirene, die an einen auf Hochtouren drehenden Motor erinnert. Überblendung auf eine hart ausgeleuchtete öde Landschaft.[8] Ein Geländewagen rast auf uns zu und schafft es gerade noch, eine riesige schwarze Wolke hinter sich zu lassen, die dräuend über dem Horizont hängt. Dann wird der Wagen in einer raschen Abfolge harter Schnitte umrundet, bis der Zuschauer erkennt, um welches Modell es sich handelt: einen Nissan Murano. Dann kommt die Wolke am Himmel immer näher, und wir erkennen, dass sie aus schwebenden Häusern besteht, die unter den Reifen des SUV verschwinden und sich dann unversehens in ein gepflegtes Vorstadt-Idyll verwandeln. Dazu singt eine

[3] «Josephine Meckseper im Gespräch mit Simone Schimpf» (wie Anm. 1, S. 20).
[4] Jean Baudrillard, *Die fatalen Strategien*, München 1991, S. 144f.
[5] Karl Marx, *Das Kapital*, Frankfurt am Main/Berlin 1969, S. 53.
[6] Siehe auch Diedrich Diederichsen, *Mehrwert und Kunst*, Rotterdam/Berlin/New York 2008.
[7] Bereits in Mecksepers Arbeit *United States of America* (2008) lassen sich etliche auch für *0% Down* bestimmende Gedanken nachweisen. Die Football-, Hamburger-, Sex- und Autodarstellungen dieses Zyklus sind in diverse martialische Motive «eingebettet». Sie können daher als Beleg dafür gelten, dass die Künstlerin sich zunächst intensiv mit den Ikonen des American Way of Life auseinandergesetzt und erst dann ihr Augenmerk spezifisch auf das Auto gerichtet hat.
[8] Meckseper hat diese Szene ausgewählt, weil sie wie ein Stück Grossstadt-Amerika erscheint, das in die irakische Wüste transplantiert ist.

Baritonstimme: «Do you *want* total war? Throw out *Christ* and bring back Thor? Do you *want* total war? Unleash the *beast* in man once more? Do you *want* total war? Dance and do the lion's roar? Do you *want* total war? Do you *want* total war? *Yes,* you want total war! *Yes,* you want total war.»

Während die Hymne des Industrial Rock erklingt, geht die monochrome Montage der Automobilspots immer weiter. Kampfjets schiessen vorbei und verwandeln sich in Saabs. Riesige I-Träger schwingen wie Pendel und verfehlen nur knapp die Pickup-Trucks unten am Boden. Sportwagen verwandeln sich in Ölspritzer und sausen durch verschwommene Streifen. Lkws und Geländewagen rasen durch Berge, am Wasser entlang und über Salzebenen. Firmenlogos, technische Daten, Produktpreise und Werbeslogans werden eingeblendet. Ein Nissan Rogue fährt durch ein Strassenlabyrinth, weicht Schlaglöchern aus. Schliesslich ein Hyundai in einer dunklen Landschaft. Schwarzblende. Dann das Logo und die Texteinblendung: «Think about it.»

Das temporeiche Video mit seinem aufreibenden Soundtrack steigert die Suggestion von Macht- und Eroberungsfantasien, die in der Autowerbung ständig bedient werden. In Schwarzweiss sind die Spots jedoch keine Fantasien mehr, sie erinnern vielmehr an *Wochenschau*-Bilder, die von der Hegemonie des Militärs berichten. Die Künstlerin selbst hat über *0% Down* gesagt: «Wenn es zum Film ein Drehbuch gäbe, hätte als Regieanweisung der Satz genügt: Zeige dem Zuschauer die enge Verbindung zwischen Automobilindustrie und den Kriegen, die um Öl geführt werden.»[9] Tatsächlich steht das US-Verteidigungsministerium nicht nur im Kampf um das Öl an vorderster Front, es ist auch aufs Engste mit der Automobilindustrie verbandelt. Sämtliche Grosskonzerne – mit Ausnahme von Tata (Jaguar) –, aus deren Produktion die in *0% Down* gezeigten Autos stammen, also Toyota, General Motors (Cadillac, Chevrolet und Saab), Ford, Nissan, Hyundai, Daimler AG (Mercedes-Benz) und Mazda, haben zwischen 2002 und 2007 Lieferverträge mit dem US-Verteidigungsministerium abgeschlossen.[10] Wenn Meckseper lediglich hätte beweisen wollen, dass auch die Automobilindustrie Bestandteil des militärisch-industriellen Komplexes ist, hätte sie bloss Kopien dieser Verträge zu zeigen brauchen. Oder sie hätte darauf verweisen können, dass die Autoindustrie sich beim Design ihrer Geländewagen (SUVs) vor allem von Militärfahrzeugen wie dem Jeep oder dem Humvee inspirieren lässt.

Freilich hätte sie mit dieser Vorgehensweise kaum jene kathartische Wirkung erreicht, die sich am Ende des Videos schlagartig einstellt: ein Bewusstsein dafür, wie viel uneingestandene Gewaltbereitschaft wir mit uns herumtragen. Und diese Erkenntnis geht mit einem Gefühl der Befreiung einher. Ein auslösendes Moment dieser Katharsis ist aber auch der Song *Total War*, der die unterschwellige Brutalität der Werbespots blossstellt. Geprägt hat den Begriff des «totalen Krieges» der deutsche General und Politiker Erich Ludendorff (1865–1937), der den absoluten Vorrang des Krieges vor der Politik behauptete. Seither wird der Begriff vor allem mit der deutschen Kriegführung im Zweiten Weltkrieg in Verbindung gebracht, als unter Adolf Hitler «die militärischen Mittel aufs Verhängnisvollste von den politischen Zielen abgespalten wurden, denen sie doch eigentlich hätten dienen sollen».[11] Unter einem «totalen Krieg» versteht man seither einen Krieg, «in dem die gesamte Bevölkerung und sämtliche Ressourcen der beteiligten Kriegsparteien zugunsten eines vollständigen Sieges eingesetzt und somit zu legitimen Zielen der Kriegsführung werden».[12] Berühmtheit erlangt hat der Begriff vor allem durch Joseph Goebbels, der am 18. Februar 1943 im Berliner Sportpalast vor einem tobenden Publikum die Frage stellte: «Wollt ihr den totalen Krieg? Wollt ihr ihn, wenn nötig, totaler und radikaler, als wir ihn uns heute überhaupt noch vorstellen können?»[13]

[9] Liam Gillick (wie Anm. 2), S. 49 f.
[10] Siehe http://www.governmentcontractswon.com/search.asp?type=dc (Zugriff am 30. Januar 2009).
[11] Hugh Bicheno, «Total War», in: *Oxford Companion to Military History*, Oxford 2001/2004. Siehe auch: http://www.answers.com/topic/total-war (Zugriff am 30. Januar 2009).
[12] Ibid.
[13] Joseph Goebbels, «Nun, Volk steh auf, und Sturm brich los! Rede im Berliner Sportpalast», in: *Der steile Aufstieg*, Zentralverlag der NSDAP, München 1944. Siehe auch: http://www.calvin.edu/academic/cas/gpa/goeb36.htm (Zugriff am 30. Januar 2009).

Der «totale Krieg» ist identisch mit dem, was Giorgio Agamben in Anlehnung an Carl Schmitt und andere Denker als «Ausnahmezustand» bezeichnet – einen Zustand, in dem die Legislative zugunsten der Exekutive entmachtet wird und die Genfer Konvention gegenüber einer Bevölkerung, deren Bürger sich in Häftlinge verwandeln, keine Anwendung mehr findet. Die Ereignisse der letzten Jahre haben gezeigt, dass das Konzept des «totalen Kriegs» bis heute nichts von seiner Brisanz verloren hat.[14] So sagte etwa George W. Bush 2002 in seiner Rede zur Lage der Nation, dass wir Terroristen ohne jede Rücksicht auf Staatsgrenzen verfolgen dürfen: «Dieser Feind betrachtet die ganze Welt als ein Schlachtfeld, daher müssen wir ihn verfolgen, wo immer wir ihn finden.»[15] Es verwundert deshalb nicht weiter, dass der damaligen US-Regierung immer wieder vorgeworfen wurde, im Irak und in Afghanistan wahllos mit militärischen Mitteln eingegriffen zu haben. Ausserdem kritisieren Organisationen wie Human Rights Watch an der US-Strategie in Afghanistan, dass sie zu wenig Rücksicht auf zivile Opfer nehme.[16]

0% Down übt aber nicht nur indirekte Kritik am rücksichtslosen Einsatz militärischer Macht, sondern verweist auch ganz direkt darauf, dass nicht nur die amerikanischen Militärstrategen und ihre Hintermänner ein Interesse an einer weiterhin ungestörten Ölversorgung haben, sondern auch die grossen US-Autokonzerne. Im Soundtrack des Videos bekommen wir zudem ganz unmittelbar zu hören, was wir auf der visuellen Ebene nur unbewusst wahrnehmen: dass nämlich diese Auto-Werbespots uns dazu drängen, nicht nur für die Sicherheit und den Luxus zu bezahlen, die allgemein mit dem Besitz eines Autos assoziiert werden, sondern auch für die militärische Aggression, die jene Stabilität des Ölnachschubs erst ermöglicht. Wir brauchen Autos, um unseren gewohnten Lebensstil aufrechtzuerhalten, und Autos wiederum brauchen Öl – folglich ist Öl eine Ware, die es notfalls auch mit Gewalt zu beschaffen gilt. Das Ergebnis ist ein ewiger Krieg für den ewigen Frieden.

Die Annahme, dass sich Frieden nur durch Dominanz erreichen lässt, geht auf jenen uralten Konflikt zwischen dem Aggressionspotenzial des Menschen und der Notwendigkeit zurück, sich gesellschaftlich zu organisieren. In seinem Essay *Das Unbehagen in der Kultur* (1929/30) hat Sigmund Freud sich ausführlich mit diesem Konflikt auseinandergesetzt. Er weist in dem Text darauf hin, dass Aggressivität zwar zur «Grundausstattung» des Menschen gehöre, jedoch unsere Beziehungen zu anderen störe und deshalb von der Gesellschaft – um ihres eigenen Überlebens willen – unterdrückt werden müsse.[17] Schon Karl Marx hat gesehen, dass diese Unterdrückung ihren Niederschlag auch unmittelbar in den (Re-)Produktionsverhältnissen einer Gesellschaft findet, obwohl das den Menschen meist nicht bewusst ist. Im ersten Kapitel des *Kapitals* hat er deshalb den berühmten Satz geprägt: «Sie wissen das [zwar] nicht, aber sie tun es.»[18]

Um exakt diesen Konflikt geht es Meckseper in ihrem Schaffen.[19] Ihre skulpturalen Displays zu betrachten, ist etwa so, wie wenn man gemächlich ein Magazin durchblättert, in dem «Horrorgeschichten aus dem Irak unmittelbar neben Unterwäschereklame» abgedruckt sind.[20] In 0% *Down* geht sie aber noch über dieses zufällige Nebeneinander hinaus und beschäftigt sich ganz unmittelbar mit dem inneren Widerspruch, der die TV-Werbung charak-

[14] Giorgio Agamben, *Ausnahmezustand,* Frankfurt am Main 2004.
[15] Wiedergegeben ist der Wortlaut der «State of Union Address», die Präsident George W. Bush am 29. Januar 2002 gehalten hat, unter: http://www.washingtonpost.com/wp-srv/onpolitics/transcripts/sou012902.htm (Zugriff am 30. Januar 2009).
[16] Human Rights Watch, «The Human Cost: The Consequences of Insurgent Attacks in Afghanistan», 15. April 2007.
[17] Sigmund Freud, *Das Unbehagen in der Kultur,* Frankfurt am Main 1997.
[18] Karl Marx und Friedrich Engels, «Das Kapital», in: *Werke. Karl Marx, Friedrich Engels,* Berlin: Dietz, 1969, S. 88 [Dies, *Das Kapital. Der Produktionsprocess des Kapitals,* 1867]. Siehe auch:
http://www.mlwerke.de/me/me23/me23_049.htm#M27 (Zugriff am 4. Februar 2009).
[19] Herbert Marcuse zufolge befindet sich die Realität heute in «einem offenen und totalen Konflikt mit ihrer eigenen Ideologie und mit ihren eigenen Verheissungen». Siehe: «The Containment of Social Change in Industrial Society», in: *Towards a Critical Theory of Society,* hg. v. Douglas Kellner, London 2001, S. 93. Meine Interpretation des Videos *0% Down* verdankt Marcuses freudianisch-marxistischer Theorie entscheidende Impulse. Wichtige Anregungen verdanke ich ferner Slavoj Žižek und den Denkern der Frankfurter Schule, vor allem Slavoj Žižeks *The Sublime Object of Ideology,* New York 1989, und Theodor W. Adornos «Prolog zum Fernsehen», in: *Kulturkritik und Gesellschaft II,* Frankfurt am Main 1977.
[20] Liam Gillick (wie Anm. 2), S. 49.

terisiert: dem Widerspruch zwischen der glatten Oberfläche ihrer Produkte und der Gewalt, die in der Welt des Konsums stets mitschwingt.

Selbst wenn die neue US-Regierung in der Irak- wie in der Wirtschaftspolitik völlig neue Wege einschlägt, lässt sich dieses Spannungsverhältnis nicht einfach aus der Welt schaffen. Präsident Obama hat im Wahlkampf versprochen, die amerikanischen Truppen aus dem Irak abzuziehen. Gegen Ende der Ära Bush hat die amerikanische Regierung den «grossen drei» der amerikanischen Automobilindustrie – Ford, General Motors und Chrysler – ausserdem unter bestimmten Auflagen Mittel aus dem 700 Milliarden Dollar schweren Rettungsfonds der öffentlichen Hand zugesagt. Um die von der US-Regierung verfügten Auflagen zu erfüllen – also massive Einsparungen vorzunehmen –, hat die amerikanische Autoindustrie die Zahl ihrer Werbespots drastisch reduziert und wirbt neuerdings – wenn überhaupt – vor allem mit dem geringen Benzinverbrauch ihrer Produkte, vor allem aber für kleinere und weniger kostspielige Modelle.

Trotzdem entlässt uns das Video nicht aus der Verantwortung, da es nicht nur auf eine einmalige historisch-politische Situation verweist. Das Spannungsverhältnis zwischen Aggression und Zivilisation, das in dem Film zutage tritt, ist nämlich auf einen prinzipiellen Konflikt zurückzuführen, der der Conditio humana gewissermassen eingeschrieben ist. Auch wenn Mecksepers Video uns an unsere Komplizenschaft im Irakkrieg erinnert, verweist es zugleich auf jene grundlegendere Destruktivität, die wir durch unsere unersättliche Konsumwut und die damit einhergehenden Werte stets aufs Neue anheizen.

Ich möchte mich bei Claudia Schmuckli, Katy Lopez und Jonathan Leach für die kritische Lektüre früherer Fassungen dieses Essays bedanken. Ihre Anregungen haben mir geholfen, meine hier dargelegten Gedanken klarer zu fassen. Danken möchte ich auch Polly Koch, die die englische Version des Textes redaktionell betreut hat, sowie Josephine Meckseper und Arianna Petrich für wichtige Hinweise und Klarstellungen.

Sylvère Lotringer

Der grosse Crash

I

Josephine Mecksepers Skulpturen und Mixed-Media-Installationen kommen besonders ein-
drucksvoll zur Geltung in den Räumlichkeiten des migros museum für gegenwartskunst,
einer ehemaligen Bierbrauerei, also einem industriegeschichtlichen Kontext. Ausserdem
handelt es sich um ihre bisher wohl direkteste und politisch expliziteste Ausstellung. Die
Geschichte klopft schliesslich nicht jeden Tag an die Tür. Genau deswegen hat Meckseper
sich wohl entschlossen, ein eindeutiges Statement zu der rasch entschwindenden Ära abzu-
geben, in der wir leben. Dabei hat sie auf jene ebenso subtile wie beunruhigende Form der
Auseinandersetzung mit der heutigen Gesellschaft verzichtet, die zu ihrem Markenzeichen
geworden ist. Die nur wenige Monate vor der globalen Kernschmelze des Finanzsystems
und dem – wie es scheint nicht mehr fernen – Kollaps der drei grossen US-Autohersteller
konzipierte Ausstellung vermittelt einen Eindruck von der Intensität einer Gegenwart, in
der sich der Kapitalismus direkt vor unseren Augen aufzulösen scheint. Sie gewährt ferner
Einblick in die Mechanismen jenes rücksichtslosen Gewinnstrebens, das zurzeit auf dem
ganzen Planeten eine Spur der Verwüstung hinterlässt, und zeigt das schier unauflösliche
Ineinander von Finanzspekulation, Politik, Wirtschaft und Krieg. Ja, die Ausstellung antizi-
piert gewissermassen das Ende der amerikanischen Dominanz in ihrer bisherigen Form und
den donnernden Kollaps jenes Modells freier Märkte, dessen weltweite Durchsetzung sich
die Vereinigten Staaten auf die Fahne geschrieben hatten. Wie hat Charles Wilson, von 1941
bis 1953 Vorstandsvorsitzender von General Motors, noch gesagt? Als Präsident Eisenhower
ihn 1953 zum Verteidigungsminister berief, musste der – zu diesem Zeitpunkt noch amtie-
rende – GM-Chef sich vor dem Senat den Fragen der Abgeordneten stellen. Auf die Frage, ob
es zwischen seinem – auch finanziellen – Engagement bei dem Autohersteller und dem Amt
des US-Verteidigungsministers nicht einen Interessenkonflikt gebe, antwortete Wilson mit
dem seither geflügelten Wort: «Was für General Motors gut ist, ist auch gut für das Land.»
Noch nie hat diese Feststellung so wahr geklungen wie heute.

Der Kollaps von General Motors, einem Konzern von globaler Bedeutung und Symbol amerikanischer Wirtschaftsmacht, wirft ein unheimliches Licht auf jene Automobilkultur, die bis vor kurzem eines der Aushängeschilder amerikanischer Macht war. Um dieser Autokultur willen haben die USA alles darangesetzt, die weltweiten Ölvorräte zu kontrollieren, und im Irak sogar einen verheerenden Krieg angezettelt. Mecksepers Ausstellung lädt dazu ein, diesen langsam verblassenden, aber noch immer wirkmächtigen imperialistischen Mythos nicht allein unter ökonomischen, sondern zugleich unter anthropologischen Vorzeichen zu betrachten. Irgendwann wird auch das Auto, ja Amerika selbst das Schicksal der Dinosaurier erleiden und im Museum enden. Genau diesen Eindruck vermitteln die hübschen Plakate, auf denen mit Plastikfolie verhüllte Autos zu sehen sind. Selbst wenn die Werbung die Produkte der Konsumgüterindustrie noch so glamourös anpreist – sind diese Artikel erst einmal ausrangiert, erinnern sie an Leichensäcke. Gewalt und Tod liegen auch heute noch überall auf der Lauer, mögen sie sich noch so sorgfältig tarnen.

Hier geht es also nicht nur um den simulationistischen Aspekt des Finanzkapitalismus, sondern auch um jene Technik, auf die er sich stützt, um seine Ziele zu erreichen. Von Paul Virilio wissen wir, dass die Technik ein Rätsel ist. Die einzig angemessene Reaktion auf dieses Rätsel besteht darin, dass wir die – meist ignorierten oder als extrinsisch angesehenen – *negativen* Seiten der Technik zur Kenntnis nehmen. Jede technische Erfindung wirft einen langen Schatten: Der Autounfall ist so gut eine Erfindung wie das Auto selbst. Flugzeugabstürze sind nicht bloss absurde Zufälle, sondern Kreationen ganz eigener Art. Dass es Autocrashs gibt, weiss jeder, dass aber auch Automobilhersteller selbst einen Crash erleiden können, wird meist verdrängt. Der Unfall gestattet einen Blick auf das Innerste der Maschine oder des Systems. Der «eigentliche Unfall», der den ganzen Planeten erschüttert, ein Unfall, wie wir ihn derzeit erleben, hat uns durchaus etwas über das Wesen des «Techno-Kapitalismus» zu sagen.

Virilio hat geholfen, den humanistischen Diskurs über die Technik zu verscheuchen – einen Diskurs, der die Technik meist unter instrumentellen und anthropologischen Vorzeichen abhandelt, als ob sie nichts weiter wäre als «angewandte Wissenschaft». Nach dieser Auffassung haben technisch hergestellte Objekte bloss den Zweck, das Leben der Menschen zu erleichtern, und Autos dienen einzig der Bequemlichkeit und der Eitelkeit des Konsumenten. Heidegger hat daran erinnert, dass das Wesen der Technik sich nicht in der Herstellung erschöpft, sondern vielmehr in der Realisierung eines elementaren Projekts oder Plans besteht. Die Technik ist nicht neutral, und ihr Projekt muss beim Namen genannt werden. Sie ist Teil eines «totalen Krieges», und die derzeitigen Kriege im Irak und in Afghanistan sind in diesem Kontext lediglich die Spitze des Eisbergs.

In seiner berühmten Rede im Berliner Sportpalast vom 18. Februar 1943 hat Joseph Goebbels den Begriff des «totalen Krieges» verwendet. Mit dieser Rede wollte er das deutsche Volk dazu aufpeitschen, nach dem Zusammenbruch der Ostfront bis zum bitteren Ende weiterzukämpfen. Der ominöse Bunker aus Virilios *Bunkerarchäologie* erinnert an die Zeit, als ganz Europa von Nord bis Süd ein einziges Schlachtfeld war – vom Westwall bis zur Maginotlinie und dem Atlantikwall. «Zugleich berührt man damit auch die mythische Dimension eines Krieges», heisst es dort, «der sich nicht nur auf Europa, sondern auf die ganze Welt erstreckt.» Bunker, Luftschutzkeller etc. «sind so etwas wie Anhalts- und Markierungspunkte für das Totalitäre des Krieges im Raum und im Mythos».[1]

Der «totale Krieg» wird aber nicht nur in Extremsituationen ausgerufen, der Begriff beinhaltet zugleich die «totale Mobilmachung» der Zivilbevölkerung in Friedens- wie in Kriegszeiten. Ernst Jünger hat sich in seinem 1938 erschienenen Buch *Der Arbeiter* als Erster mit der Frage der «totalen Mobilmachung» beschäftigt und darauf hingewiesen, dass ein begrenztes Budget nicht ausreicht, um die Kosten eines totalen Krieges zu decken. «Neben den Heeren, die sich auf den Schlachtfeldern begegnen, entstehen die neuartigen Heere

[1] Paul Virilio, Sylvère Lotringer, *Der reine Krieg*, Berlin 1984, S. 8.

des Verkehrs, der Ernährung, der Rüstungsindustrie – das Heer der Arbeit überhaupt.[2] Fortan werden Schlachten nicht mehr auf dem Schlachtfeld, sondern in der «Schlacht der Bewegung» entschieden, so Jünger. In demselben Essay heisst es aber auch, dass die «totale Mobilmachung» nicht etwa darin besteht, dass die gesamte Bevölkerung für die Armee rekrutiert oder auf das Schlachtfeld entsandt wird, sondern in der «Bereitschaft» der Menschen zu einer solchen Mobilisierung.

Virilio bezieht sich in seiner eigenen Theorie des «reinen Krieges» – eines Krieges, der geführt werden kann, ohne dass es zwangsläufig zu konkreten militärischen Auseinandersetzungen kommt – immer wieder auf dieses Konzept. Das perfekte Beispiel eines solchen Krieges war der Kalte Krieg. Obwohl in dieser Ära in diversen Ecken der Welt (Korea, Vietnam, Afghanistan etc.) durchaus blutige Kriege ausgetragen wurden, hinderten sich die beiden Blöcke durch ihre «Abschreckungs»-Potenziale wechselseitig daran, den letzten Schritt zu tun. Vielmehr verlegten sie sich zur Durchsetzung ihrer jeweiligen Ziele auf eine ökonomische und technologische Eskalation. Diese Verschmelzung von Wissenschaft und Krieg hob die Unterscheidung zwischen ziviler und militärischer Sphäre endgültig auf. Anders als Virilio hat Jünger sich ausführlich zu den gesellschaftspolitischen Implikationen dieser Mutation geäussert. Er definiert den «Arbeiter» als «neue Wirklichkeit», ja sogar als «neue Rasse», der es bestimmt ist, den Bourgeois wie den Proletarier abzulösen. Das Arbeitsheer wird fortan nicht mehr in Industrieghettos verbannt, vielmehr verwandelt sich die ganze Gesellschaft in einen unmittelbar für den Dienst am Krieg bestimmten «totalen Arbeitsraum». Jünger zufolge ist die Gestalt des Arbeiters das beherrschende Element in dieser neuen Wirklichkeit. Er feiert die Technik als eine dämonische Macht, die alle individuellen, aber auch sämtliche Differenzen zwischen den Klassen und Nationen auslöscht. Was der Arbeiter dabei an Individualität einbüsst, gewinnt er an Präzision und Objektivität. So wird die Arbeit zum Quell und zur höchsten Bestimmung des ganzen menschlichen Daseins. «Verändert hat sich auch das Gesicht, das dem Beobachter unter dem Stahlhelm oder der Sturzkappe entgegenblickt… Es ist metallischer geworden, auf seiner Oberfläche gleichsam galvanisiert, der Knochenbau tritt deutlich hervor…»[3]

So hat sich entsprechend den Bedürfnissen einer neuen technischen Welt eine neue *metallische* Rasse entwickelt. Von lebensgrossen insektenartigen Öltiefpumpen aus Stahl bis hin zu verchromten Autokennzeichen, von abstrakt gehaltenen Radfelgen bis hin zu metallbeschichteten Schaufensterpuppen ist in Mecksepers Ausstellung ein Technikrennen zu besichtigen, in dem sämtliche Gattungsgrenzen fallen. Dazu gehört auch der martialische Saab-Werbespot. In diesem Spot, der von Industrial-Musik aus den neunziger Jahren untermalt wird, donnern im Hintergrund Kampfjets vorbei, während der Sänger immer wieder ironisch die Frage stellt: «Do you want total war?»

In Jüngers Augen ist dieses entindividualisierte «neue Menschentum» eine Kampf-«Elite», die dank einer «höheren Legalität» dazu ausersehen ist, Spezialaufträge zu übernehmen. 1934 bejubelte er sogar die Aktivitäten japanischer Kamikaze-Piloten als neue Form eines «nietzscheanischen Humanismus». Wegen der rasanten Entwicklungen im Bereich der digitalen Elektronik, zu denen es im vergangenen Jahrzehnt gekommen ist, lässt sich diese Elite heute jedoch nicht mehr so leicht identifizieren; tatsächlich ist sie inzwischen mehr oder weniger zu einem Massenphänomen geworden. Die «äusserste Kälte» der metallischen Gesichtszüge hat sich nach innen verlagert, ohne deswegen etwas von ihrem metallischen Charakter einzubüssen. Gilles Deleuze bezeichnet die Angehörigen dieser neuen Rasse, die mit ihren Mobiltelefonen und Kreditkarten wie mit Waffen herumfuchteln, als «Dividuen».
Zwar sind die zerstörerischen Folgen dynamischer Vehikel leicht auszumachen, aber auch eine technische Gewalt, die dem blossen Auge verborgen bleibt, ist deswegen nicht minder folgenreich. Tatsächlich sind diese Konsequenzen sogar umso weitreichender, je weniger

[2] Ernst Jünger, «Die totale Mobilmachung», in: *Sämtliche Werke – Zweite Abteilung – Essays I: Betrachtungen zur Zeit*, Bd. 7, Stuttgart 1980, S. 125.
[3] Ernst Jünger, *Der Arbeiter – Herrschaft und Gestalt*, Stuttgart 2007, S. 112.

explizit sich Gewalt zeigt. Und so wandert die Gewalt zusehends in die kaum fassbaren Waffensysteme der Kommunikation – und damit die visuellen Techniken wie Fotografie, Film, Fernsehen, Video und die neuesten elektronischen Medientechnologien. Sie alle sind indirekte Abkömmlinge der Militärforschung und einer *Star Wars*-artigen Technik der Abschreckung, die sich immer mehr dem absoluten Tempolimit der Lichtgeschwindigkeit annähert und die Welt des Menschen mit einer ganz neuen Form des Krieges überzieht. Die Echtzeit der Telekommunikation schafft die Unterscheidung zwischen der Realität und den Bildern davon ab und verdrängt die konkrete physische Erfahrung der Realität durch eine virtuelle Form der Vergegenwärtigung. Diese «Transparenz» ist der grösstmögliche Unfall, den die «Sehmaschinen» verursachen, da die Geschwindigkeit der Bilder an die Stelle der konkreten physischen Bewegung getreten ist. Augenblickliche Präsenz und Omnipräsenz verdrängen allmählich die Erinnerung an die Geschichte und verursachen eine Entwirklichung der Wirklichkeit. Die moderne Technik hat unser Verhältnis zur Welt drastisch verändert. Heidegger fasst diese technisch-wissenschaftliche Zurichtung der Welt unter dem Begriff des «Weltbilds» zusammen. Die Durchsetzung der «Augenblickszeit» auf globaler Ebene kündet bereits vom prinzipiellen Verschwinden des Sozialen. Die Technik der Kriegsführung und die Techniken der Wahrnehmung fallen heute in eins.

Paul Virilio
Der totale Unfall
Ein Interview mit Sylvère Lotringer

Sylvère Lotringer: *Uns läuft die Zeit davon. Heute geschieht alles in Echtzeit, nur dass die Zeit selbst offenbar immer weniger als real erfahrbar ist. Und das gilt auch für die Geschichte.*

Paul Virilio: Wir haben es heute nicht mehr mit der Trilogie Vergangenheit/Gegenwart/Zukunft zu tun. Was wir heute erleben, ist nicht nur eine Beschleunigung der Geschichte, sondern auch des Augenblicks. Der Augenblick ist nicht gegenwärtig. Der Augenblick der Unmittelbarkeit und der Omnipräsenz hat nicht an der Gegenwart teil. Er hat vielmehr eine eher zufällige Autonomie gewonnen.

In der Vergangenheit haben die Historiker der Annales-Schule die Archive durchforscht und sich vornehmlich mit zwei historischen Kategorien befasst: den langen Perioden à la Braudel. Fernand Braudel, Marc Bloch, Lucien Febvre haben sich vor allem für die allgemeine Geschichte (Jahrhunderte und ganze Kulturen) interessiert. Daneben gab es noch die Ereignisgeschichte – etwa des Ersten Weltkriegs, der Französischen oder der Russischen Revolution. Jetzt schreibt sich der Historie ein neues Element ein, das in der Instantaneität begründet ist. Wir kennen zwar noch immer Zeiträume von grosser Dauer oder den Zeitrahmen bestimmter Ereignisse, die an der Gegenwart teilhaben (der Gegenwart der Revolution von 1789, der Gegenwart der Russischen Revolution), aber wir nähern uns der Möglichkeit einer akzidentellen Historie – einer Geschichte, die nichts verbindet, und zwar weder in der Vergangenheit noch in der Gegenwart, noch in der Zukunft. Die Geschichte als Ereignis ist inzwischen durch eine akzidentelle Geschichte verdrängt worden – eine Geschichte ohne Bezugspunkte. In diesem Sinne ist sie ein Akzidenz oder ein Unfall der Zeit.

Der unüberbietbare Erfolg

Die Globalisierung erweist sich zusehends als Desaster. Der Planet schrumpft mehr und mehr zusammen, und uns geht allmählich der Raum aus. Wir hocken sozusagen aufeinander, und zwar in doppelter Hinsicht. Bereits der Flügelschlag eines Schmetterlings reicht aus, um den ganzen Planeten in Aufruhr zu versetzen. Sollten wir uns wieder deglobalisieren, um aus diesem Schlamassel herauszukommen?

Daher rührt ja das ganze Interesse an den Exo-Planeten, an der Exo-Biologie, an der Exo-Wissenschaft, wie ich das nenne. Mit anderen Worten: Wir zetteln das ganze Kolonialprojekt jetzt von neuem an: diesmal allerdings im *Weltraum*. Der Cyberspace ist schon heute eine Kolonie, die die konkrete Welt verdrängt. Der Sechste, der virtuelle Kontinent ist bereits heute so was wie eine neue Kolonie, eine Art Vorbereitung auf die Emigration in den Weltraum. Die Suche nach Exo-Planeten mit Hilfe von Raumsonden etc. führt aber nicht zur Entdeckung einer anderen Welt – wie damals in Amerika –, sondern in einen Raum *jenseits* der Welt.

Auf planetarischer Ebene würde ein eigentlicher Unfall möglicherweise eine Kettenreaktion von Katastrophen auslösen. Ist es das, was wir aus der Katastrophe lernen können?

Nein, aus der Katastrophe können wir lediglich lernen, wie es zu dem Unfall gekommen ist. Der Unfall ist unauflöslich mit dem Fortschritt verbunden. Genau das hat Hannah Arendt

gemeint, als sie sagte: «Der Fortschritt und die Katastrophe sind die Vorder- und Rückseite derselben Medaille.» Je mehr der Fortschritt sich entfaltet, als umso unüberwindlicher erweist sich die Katastrophe. Seit dem Ende des 20. Jahrhunderts sind wir in eine Ära des unüberbietbaren Erfolgs eingetreten: Die Welt ist für den Fortschritt zu klein geworden.

Das heisst, sie war allzu erfolgreich.

Ja, sie war zu erfolgreich und hat sich abgeschottet, sich selbst eingeschlossen. Das erklärt auch, weshalb so viele Leute in Versuchung geraten, sich in geschlossenen Wohnanlagen oder in Hochhäusern abzuschliessen, die den Mythos von Babel wiederholen, also in gewisser Hinsicht das Prinzip der Katastrophe in Szene setzen. Die Katastrophe ist ein uneingestandenes Wissen, von dem wir nur Kenntnis nehmen, wenn es zu einer technischen Katastrophe kommt. Und genau darum geht es mir: Künftige Universitäten werden die Katastrophe des Fortschritts erforschen. Sämtliche Teilbereiche des Wissens sind gehalten, sich an der Barbarei des Fortschritts zu beteiligen. Die europäischen Universitäten wurden in Bologna, an der Sorbonne und später in Salamanca um die Barbarei herumgebaut – die Barbarei der Geschichte. Und genauso müssen wir nicht etwa im Jahr 1000, sondern heute – im Jahr 2000 – eine Universität neu erfinden, die sich der Katastrophe widersetzt – dem katastrophalen Erfolg des technisch-szientistischen Fortschritts auf den Feldern der Nuklearwissenschaft, der Informationstechnik und der Genetik, Einsteins drei Bomben. Möglich geworden ist die Atombombe erst dank der Informationsbombe, die auch die genetische Bombe hervorgebracht hat – durch die Kartierung des menschlichen Genoms und die damit einhergehenden Verfahren des Klonens und der Erzeugung von Mischwesen etc. Deshalb müssen wir an den heutigen Universitäten das Äquivalent des in der Automobilindustrie üblichen Crash-Tests entwickeln. Bei der Gelegenheit möchte ich daran erinnern, dass ein Crash-Test Bestandteil der Geschichte ist.

Der Finanzunfall

Vor ein paar Jahren haben wir uns ausführlich über eine Finanzkrise unterhalten, die den totalen Unfall auslöst. Damals hast du gesagt, dass sie geradezu spektakulär bestätigen werde, was du in deinem Buch über den Unfall darlegen möchtest. Dieser integrale – dieser eigentliche – Unfall passiert zurzeit direkt vor unseren Augen.

Ja, das Wasser steht uns tatsächlich schon bis zum Hals. Der Crash ist das Modell des totalen Unfalls. Weshalb? Weil er zusammen mit dem Krieg das klassische Beispiel der Instantaneität ist. Ich darf daran erinnern: Wenn Zeit Geld ist, dann ist Geschwindigkeit Macht, die *Macht* des Geldes, nicht bloss Geld. Die Crash-Serie der letzten Jahre, zum Beispiel der Crash in Japan – die dortige Hypothekenkrise, die das Land, dem es vorher so gut ging, völlig destabilisiert hat –, das Gleiche passiert jetzt in den Vereinigten Staaten, und es wird überall passieren. Und das hat alles nichts mit dem Börsenkrach von 1929 zu tun.

Darüber habe ich mich vor kurzem mit meinem alten italienischen Freund Christian Marazzi unterhalten, der in der Schweiz ein bekannter Ökonom ist. Er hat mir erzählt, dass er angefangen habe, sich mit der Katastrophentheorie zu beschäftigen, weil er begriffen habe, dass wir unmöglich wissen können, wohin das alles noch führe. Er meint, dass es mindestens noch zwei Jahre dauere, bis wir das volle Ausmass der Krise überblicken können. Bislang haben wir noch nie eine Situation erlebt, in der das gesamte Finanzsystem zusammenbrechen könnte.

Richtig. Anfang der achtziger Jahre hatte ich die Idee, ein Unfallmuseum zu gründen, wie ich das damals genannt habe. Zu der Zeit war [der Sozialist] Jack Lang gerade fran-

zösischer Kulturminister und François Barré Leiter des Centre Pompidou. Die *Art Press* hat mich damals zu den Schlachthausruinen von La Villette interviewt, und François Barré wollte von mir wissen: «Was sollten wir Ihrer Ansicht nach mit diesen Ruinen machen? Sie interessieren sich doch für Ruinen.» Ich habe ihm geantwortet: «Ich würde dort ein Museum für Wissenschaft und Technik einrichten.» Darauf er: «Genau das ist auch geplant.» Und ich: «Das ist perfekt.» Dann hat er gefragt: «Und was für ein Programm würden Sie dort machen?» Und ich habe gesagt: «Es ist klar, dass dort jede Disziplin des Wissens nicht nur ihre Erfolge, sondern auch *ihre Katastrophen* zeigen sollte.» Was den Charakter der für die jeweilige Disziplin typischen Katastrophe anbelangte, sollte es keine Zensur geben. Natürlich hat mich niemand nach meiner Meinung zu La Villette befragt – merkwürdigerweise hat man sich bei anderen Gelegenheiten durchaus an mich gewandt, aber nicht im Zusammenhang mit diesem Projekt. Und wann hat die «Cité des Sciences – La Villette» ihre Tore geöffnet? Das war 1986 – also im selben Jahr wie Tschernobyl und die Challenger-Katastrophe. Ich wollte damals wieder einen Artikel in *Art Press* veröffentlichen. Ich weiss noch, dass du mich damals interviewt und gesagt hast, dass das Fernsehen das eigentliche Unfallmuseum ist. Und dass die Wissenschaftler unfähig sind, sich mit dieser Frage auseinanderzusetzen. Seither ist alles noch viel grösser geworden. Wir haben gesehen, wie das Raumschiff Columbia auseinandergeflogen ist etc.

Das heisst: zuerst der Reaktorunfall und der Space-Shuttle-Unfall und jetzt der Finanzunfall?

Genau.

Hast du vorausgesehen, dass sich so etwas abzeichnet?

Ich habe schon immer geglaubt, dass der Finanzunfall, der Finanz-Crash das Modell des integralen Unfalls ist, weil er mit der höchsten Geschwindigkeit die Konsequenzen des Irrtums oder des Hyper-GAUs der Börsenkurse projiziert. Wenn es einen Ort gibt, an dem Hyperunfälle passieren, dann in der Wallstreet. Jeden Tag kann ein Unfall weitere Unfälle auslösen. Genau darum kreist der Markt.

Aber dieser Crash war durch die zeitliche Gleichschaltung der Märkte bedingt.

Auch hier gilt wieder: Wenn Zeit Geld ist, dann ist Geschwindigkeit Macht. Deswegen lassen wir uns überhaupt auf ein Wettrennen ein. Was ist ein «Wettrennen»? Das Wort bedeutet, dass Macht gewinnt, wer zuerst ankommt. Gleichzeitig sitzen wir aber auf einem Pferd, steuern ein Auto oder gehen zu Fuss. Es ist ganz klar, dass Geschwindigkeit gleich Macht und Macht gleich Geschwindigkeit und Instantaneität, Allgegenwart und Unmittelbarkeit Prärogative des Göttlichen sind.

Das gilt für die Geschwindigkeit, aber was die Macht anbelangt, ist es schwierig, zu sagen, wo sie derzeit verortet ist.

Für gewöhnlich gestattet es uns die Geschwindigkeit zu *sehen*. Das ist etwa beim Fernsehen der Fall. Beim Online-Streaming zum Beispiel können wir dank der Übertragungsgeschwindigkeit sehen, was gerade woanders passiert. Deshalb ist klar, dass Geschwindigkeit die Macht des Sehens ist. Und sie sollte auch die Macht des Vorhersehens, des Vorhersagens sein. Aber das ist nicht der Fall. Das ist, glaube ich, ein grosses Tabu, ich meine damit den Umstand, dass in einer Welt des Fortschritts niemand die Freiheit besitzt, sich rational zu verhalten.

Ist die Welt zurzeit nicht völlig irrational?

Ja, aber alle schwören, dass sie total vernünftig eingerichtet ist. Und das ist der grosse Bluff, der Kartentrick. Nur ein Wort: Ich bin nicht etwa gegen den Fortschritt der Wissenschaft, sondern gegen den Fortschritt der *Techno-Wissenschaft*. Ich wende mich gegen die Instrumente, die diese Wissenschaft hervorbringt, worin auch immer sie jeweils bestehen mögen. Sobald wir anfangen, Instrumente herzustellen, sollten wir sie an den von Karl Popper entwickelten Kriterien messen, das heisst, sie testen.

Die Krise der Politik

Die Krise der Politik. Damit meine ich, dass Regieren im globalen Kontext im Rahmen des Staates nicht mehr möglich ist. Wieso das? Weil im Wirtschaftsleben Computer und mathematische Programme den Ton angeben und nicht zu übersehen ist, dass sie die globale Ökonomie nicht zu steuern vermögen. Das zeigt auch der Skandal um den Aktienhändler Jérôme Kerviel in Frankreich, und das gilt ebenso für die derzeitigen Geschehnisse in den USA. Wenn wir uns die zurzeit politisch Verantwortlichen überall auf der Welt anschauen – ob nun Sarkozy, George W. Bush, Berlusconi oder Putin, die Liste ist endlos –, findet man unter diesen Leuten keinen Einzigen, der den Herausforderungen der Globalisierung oder der Endlichkeit gewachsen wäre. Wenn früher jemand gesagt hat: «Ich will Herr der Welt sein», hat man ihn eingesperrt. Heutzutage haben diese Männer zwar die Macht, die Endlichkeit zu managen – dabei ist unsere Endlichkeit nicht etwa die Apokalypse, sondern die Eingeschlossenheit –, doch keiner von ihnen ist dieser Situation gewachsen, sie übersteigt schlichtweg ihre Fähigkeiten. Und die Frage der Demokratie wird sich demnächst ebenfalls stellen.

Schon vor Jahren haben wir über den Begriff der «Transpolitik» diskutiert. Führt die Globalisierung wirklich dazu, dass politisches Handeln unmöglich wird?

Die Fähigkeit, politisch zu handeln, hing bislang mit der Vergangenheit, mit dem historischen Fortschritt zusammen. Wenn es die Demokratie gibt, dann weil es die Griechen gegeben hat. Wenn es die Monarchie gegeben hat… etc. Somit war die politische Wissenschaft in gewisser Hinsicht mit der Geschichte des Regierungswissens verbunden – egal, ob dieses Wissen einen religiösen oder säkular-republikanischen, einen royalistischen oder einen demokratischen Erfahrungshintergrund hatte. Aber jene Beschleunigung der Geschichte, die den Blitzkrieg hervorgebracht hat, also den Zweiten Weltkrieg – und vergiss nicht: ich bin ein Kind des Zweiten Weltkriegs, des Blitzkriegs –, hat auch den Unfall der Geschichte verursacht. Das 20. Jahrhundert – Camus zufolge «ein unversöhnliches Jahrhundert» – ist beides: Auschwitz und Hiroshima. Doch die Beschleunigung der konkreten Zeit, also die reine Unmittelbarkeit, ist politisch nicht beherrschbar. Keine Art von Politik ist diesem quasigöttlichen Ereignis gewachsen. Die Weltökonomie und -ökologie in Echtzeit zu steuern, ist schlicht unmöglich, es sei denn, wir erneuern die Grundlagen der Politik, wie die Griechen es am Ursprung der Geschichte getan haben. Und dann zeigt sich wieder… Ich habe das Buch *L'austérité et la vie morale* von Vladimir Jankélévitch wiederentdeckt, einem Mann, den ich als grossen Lehrer betrachte. Das Buch, in dem er über die Genügsamkeit des moralischen Lebens spricht, ist heute vergriffen. Trotzdem ist dieses Buch für die heutige Welt viel wichtiger, als uns bewusst ist. Was ist Ökologie? Selbstdisziplin. Ganz klar, sie ist nicht etwa Dekadenz, sondern Genügsamkeit. Niemand vermag heute die wahren Grundlagen ökologischer Selbstbeschränkung, ihre Tragweite ganz zu ermessen – ebenso wenig die Schwierigkeiten, vor die sie uns stellt. Alle, auch Sarkozy, sagen: «Das kriegen wir schon hin, alles halb so schlimm, kein Grund zur Sorge.»

Genügsamkeit bedeutet, dass weniger mehr ist.

Ja, die Tugend von morgen heisst Demut. Teresa von Ávila hat gesagt: «Demut ist Wahrheit.» Diesen Ausspruch wird sich die Politik künftig zu Herzen nehmen müssen. Es sei denn, wir reaktivieren den Kolonialismus und installieren auf irgendwelchen Planeten im Weltraum ein neues Imperium etc. In einer Zeit, da der Kolonialismus – das französische, das britische Kolonialreich – so heftig kritisiert wird, fühlt man sich fast zu dem Kommentar gedrängt: «Und jetzt also wieder alles wie gehabt – nur diesmal im Weltraum! Herzlichen Glückwunsch!»

Was können wir denn von der Politik noch erwarten – ausser der Verwaltung der Katastrophe? Den Politikern fällt doch nichts weiter ein, als die Katastrophe noch zu befeuern.

Die Katastrophe des Fortschritts ist die Katastrophe des Erfolgs. Eine paradoxe Logik. Das Problem ist nicht, dass ein Atomkraftwerk in die Luft gehen könnte, sondern dass wir weiterhin Atomkraftwerke bauen. Wenn ein Atomkraftwerk havariert, so ist das lediglich ein technisches Versagen, selbst wenn Zerstörungen damit einhergehen. Etwas anderes aber ist es, wenn man unter dem Vorwand der Endlichkeit der fossilen Rohstoffe (zum Beispiel der Kohle oder des Öls) immer neue AKWs baut. Das ist eine ganz andere Dimension der Katastrophe. Die wachsende Zahl neuer Atomkraftwerke – also ihre erfolgreiche Proliferation – ist eine viel grössere Bedrohung als die Erschöpfung der Energieressourcen. Leider ist nicht zu übersehen, dass das Konzept der Atomenergie wieder en vogue ist – und das zwanzig Jahre nach Tschernobyl.

Sogar taktische Nuklearwaffen sind neuerdings wieder ein Thema. Das alles kommt jetzt wieder zur Hintertür herein.

Der Atomkrieg, die Proliferation… Das Zeitalter der Abschreckung ist passé. Die Proliferation setzt die Abschreckung buchstäblich ausser Gefecht.

Wo ist in der Katastrophe der Ort des Todes, des Kamikaze?

Ich habe mich in meinem *Essai sur l'insécurité du territoire* mit dem suizidalen Zustand beschäftigt. Dieser Zustand war eine lokale Figur, die Figur einzelner Staaten, einzelner Individuen, sozialer Klassen, die sich diesem Selbstmord verschreiben konnten. Wir haben das im Zweiten Weltkrieg in Japan gesehen, heute sehen wir es wieder im integralen, im fundamentalistischen Islam. Wir sehen, wie sich der suizidale Zustand (engl. «suicidal state») auf politischer Ebene tatsächlich zum Staat aufschwingen kann.

<u>Ein Katastrophenstaat</u>

Das wäre ein katastrophaler Zustand. Wir haben das in Nazi-Deutschland schon mal gesehen. Der totalitäre Staat war ein Katastrophenstaat.

Als der Kaiser von Japan erkannte, dass der Krieg verloren war, hat das japanische Militär die Idee eines nationalen Selbstmords propagiert – die ganze Nation sollte Selbstmord begehen. Die Japaner mussten sich dem Militär widersetzen, um durchzusetzen, dass die Niederlage akzeptiert wurde.

Und jetzt stehen wir am Rand einer internationalen Katastrophe.
Heute befinden wir uns nicht mehr auf einer nationalen Ebene, gleichzeitig erleben wir eine Mobilisierung der Kamikaze-Kämpfer. Aber die Situation ist schon wieder sehr ähnlich. Die Zahl freiwilliger Kamikaze-Kämpfer, der Selbstmord im Namen der Religion, das alles ist schon ein sehr bedrohliches, ein epidemisches Phänomen. In Japan war das ein Projekt des

Kaisers; im heutigen Islam dagegen handelt es sich um ein Projekt, das aus dem Körper der Gesellschaft entspringt. Hier ordnet kein Staat den nationalen Selbstmord an, vielmehr gibt es eine «grosszügige Bereitschaft» zum massiven Selbstmord. Hier geht es also nicht mehr um Massenvernichtungswaffen, sondern um Massen, die sich selbst zerstören, die selbstzerstörerisch sind. Das Kamikaze-Prinzip ist tatsächlich eins der grössten Probleme. Aber es kommt aus Japan.

Glaubst du nicht, dass wir es hier einerseits mit einem individuellen Akt zu tun haben, andererseits aber mit einer Kollektivreaktion? Die Kamikaze-Kämpfer sind eine Reaktion auf das Kamikaze an unserer eigenen Kultur.

Richtig. Die Erfindung der Atombombe war ein historischer und wissenschaftlicher Unfall, ausserdem eine wissenschaftliche Sünde. Oppenheimer hat ja selbst gesagt: «Im strengsten Sinne des Wortes ... haben die Physiker gesündigt.» Damit wollte er ausdrücken: Vielleicht sind wir zu weit gegangen. Tatsächlich hat die Wissenschaft da eine Verantwortung übernommen, die sich als tödlich erwiesen hat. Sie hat ihr Schicksal mit einem Krieg verknüpft und ist darüber selbst tödlich geworden.

Die islamischen Kamikaze-Kämpfer bringen etwas zum Vorschein, was wir bisher übersehen haben: dass wir uns in einem suizidalen Zustand befinden.

Ja, das ist ein Spiegeleffekt. Den suizidalen Zustand hat es im Zweiten Weltkrieg gegeben – in Deutschland. Hitler konnte zwar einen nationalen Selbstmord nicht anordnen, aber bevor er starb, befahl er noch, alle Leute zu vergiften und sämtliche Militäranlagen zu zerstören etc. Eine suizidale Logik. Und für die Wissenschaft – genauer: für die Techno-Wissenschaft – war die Erfindung der Atombombe Selbstmord. Daher der Ausspruch des Wissenschaftlers: «Im strengsten Sinne des Wortes ... haben die Physiker gesündigt» – eine wissenschaftliche Sünde.

Kurz gesagt: Unsere suizidale Tendenz fällt von aussen auf uns zurück. Jetzt erkennen wir diese Tendenz, weil sie uns gleichzeitig in Gefahr bringt.

Ein solches Aussen gibt es nicht mehr. Genau das bedeutet Globalisierung: Wir sind alle in Haftung, allesamt eingeschlossen. Es gibt eine Haftung der Geschichte, die der Reduzierung der Welt auf einen Augenblick entspricht. Früher war die Welt mal gross, endlos, unermesslich, deshalb wurde sie als «Welt» bezeichnet, nicht als «Universum», sondern als «Welt». Und diese Welt ist gerade dabei, sich selbst abzuschliessen, und zwar wegen der Beschleunigung in allen Bereichen: Beschleunigung des Informationsflusses, Beschleunigung des Verkehrs, Beschleunigung der Konsequenzen. Churchill hat gesagt: «Wir sind alle in das Zeitalter der Konsequenzen eingetreten.» Das hat er 1939 gesagt, direkt nach München, und heute gilt dies im globalen, nicht bloss im europäischen Massstab oder in den räumlichen Koordinaten des Zweiten Weltkriegs. Wir sind in das Zeitalter der ökologischen und der ökologistischen Konsequenzen eingetreten. Ich benutze immer das Wort «Ökologistik». Ökologie ist Ökologistik. Sie ist die Beschleunigung des Verkehrs und der Informationsübertragung – Instantaneität, Ubiquität, Unmittelbarkeit. Cioran schreibt in seinem Buch *Die verfehlte Schöpfung* den Satz: «Wir sind am Grund einer Hölle, von der jeder Augenblick ein Wunder ist.» Der böse Demiurg ist die Techno-Wissenschaft, und ihr Fortschritt sorgt dafür, dass wir verschwinden.

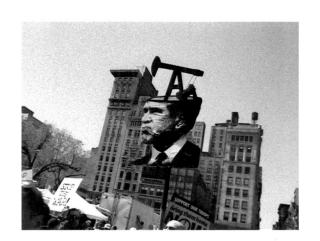

Heike Munder

The Most Elegant Corruption
of Contemporary Culture

Noam Chomsky, one of North America's leading intellectuals, has been interna-
tionally as a sharp critic of US foreign policy ever since his provocative writings on the
subject during the Vietnam War. He tirelessly gathers information, piecing it together
like a mosaic, to show a bigger picture of a US administration in quest of hegemony and
global domination, driven by the notion that the world functions like a huge circuit of
commodities, money and labor operating to satisfy the economic interests of the Ameri-
can power elite. In pursuit of this quest, according to Chomsky, the media plays a crucial
role, in particular in justifying it to a broad sector of the population by constructing ever-
new terror scenarios to suggest a constant threat from outside.

Chomsky's notoriously clear-cut analyses have, on occasion, been criticized as overly simplistic. Yet the moral vigilance and uncompromising opposition to the establishment that he has maintained for more than 40 years lay an interesting foundation for discussing the oeuvre and working methods of artist Josephine Meckseper. In an entire series of new works created from 2007 to 2009, Meckseper addresses the phenomenon of US American hegemonial aspirations, the current decline of American consumerism in a situation of unprecedented economic crisis, and the media-fuelled fear of terrorism that shapes everyday culture.[1]

In her video Mall of America (2009), Meckseper looks at the Minneapolis shopping mall of the same name that is the biggest of its kind in North America. She explores the unfettered perversion of American consumerism—the mall has more than 500 shops, fun parks, cinemas, night clubs, restaurants and hotels. It also includes a military recruitment center that looks, at first glance, like a souvenir shop. Inside, in multi-media format, young men and women are promised adventure, team spirit and camaraderie if they join the US Army. The mall seems just the right location for a facility like this. Mall of America is, after all, advertised as the meeting point and agora of the nation. Visitors are meant to feel relaxed, and safe enough to perceive the mall as somehow representing a better reality than everyday life. Meckseper softly tints the film footage of the shops and shoppers in the red, white and blue of the American flag. In spite of the fact that they are staged, the recruitment films seem strangely "real." The colors, slow-motion footage and eerie electronic sounds make this cinematic stroll through the mall feel like an almost surreal nightmare. What it affirms is not the insidious idea of a better life, but the impression of a society in decay.

In her 2008 installation Ten High, Meckseper addresses the unfolding economic crisis and the situation in the US during the presidential election campaigns of Barack Obama and John McCain. On a gleaming black Plexiglas platform—reminiscent of oil in both color and sheen—are three silver mannequins. One of them holds a sign that reads, "Going out of business. SALE," directly referring to the deep recession taking hold in the US. Another wears a tie with Christian emblems representing the highly conservative, gun-toting values of America's Bible Belt. At the mannequin's feet is a Mustang car advert mounted on aluminum. The third mannequin, wearing a T-shirt with the slogan "If You Love Your Freedom, Thank a Vet," has only one arm. Leaning against it is a mirror that looks as if it has been used for target practice. In front of the mannequin, in what seems to be a provocative commentary on the latest generation of US war veterans, is a walker with a whisky bottle, ashtray, and Bible. Meckseper's glossy displays morph into an acerbic commentary on the dark side of the Bush years: a faltering economy, Christian fundamentalism, the victims of war, and the military veterans, many of whom live in abject poverty, in sharp contrast to their glorification by the media and politicians, especially during McCain's presidential campaign.

In Thank a Vet (2008), Meckseper addresses the veteran theme even more concretely. Instead of glossy consumer goods, this portrait of a "true defender" of US freedom consists of a number of everyday items on a mirrored platform: an oil canister, a toilet brush and rug, stockinged legs and a headless, armless torso in a "Thank a Vet" T-shirt. Here, as in Ten High, the artist seeks to demystify politically charged symbols. In Blackwater, No Country for Old Men (2008), Meckseper makes an equally striking point about the fusion of business and military interests, with particular reference to the US company Blackwater, which has been operating as a private security contractor in the Iraq war. Meckseper shows the company's distinctive paw print logo, along with photos of John McCain and a walker, on a mirrored surface with the words "No Country for Old Men," in reference to the acclaimed 2007 Coen brothers' film. Blackwater was recruited and deployed to Iraq as a subcontractor of Halliburton, a company previously run by then Vice President Dick Cheney for five years before he took office. Although the company

[1]
The relationship between the culture industry and war is explored by Tom Holert and Mark Terkessidis in their controversial but stimulating book Entsichert (2002) in which they analyze the aggressive visual language used in films such as Wall Street (1987) and Boiler Room (2000), as examples of former war zones from Vietnam to the Balkans and the 9/11 attacks.

and its mercenaries should have been held accountable for the murder of civilians, the Justice Department informed Congress that there were serious legal obstacles to pursuing the criminal prosecution of Blackwater under either military or civilian law. Not only did the USA ensure that they were immune from prosecution in Iraq, but the Bush administration also refused to recognize an international tribunal. In addition, Blackwater has been linked with substantial donations to Republican causes and right-wing Christian groups. In short, a war profiteering system emerged as one of the darkest chapters of the Bush administration. Republican presidential candidate John McCain's lobbyist connections to Blackwater made negative headlines and rekindled the issue of the old boys' network. Meckseper does not present these connections in narrative form. Instead, she uses an arrangement of individual images on the mirror surface to show the tangled web of politics.

[2]
See Noam Chomsky, *Media Control: The Spectacular Achievements of Propaganda*, New York: Seven Stories Press, 1997.

This raises the question of how long such metaphors, referring as they do to a specific historical situation, remain legible for the viewer. The same question applies to Noam Chomsky's writings. Their relevance and immediacy make his writings, like Josephine Meckseper's works, an important chronicle of a time of increasingly widespread distortion and repression of facts. Apart from the obvious formal differences, Chomsky, unlike Meckseper, makes forecasts. Of course, in retrospect, such forecasts do not have the same significance as when they were actually formulated, when they seized upon the immediate fears of society. Meckseper takes society's fears and holds them up like a distorting mirror, but unlike Chomsky she bases her work on a conceptual idea rather than an ideological standpoint. However, in her latest works, discussed here, the artist is interested, much as Chomsky is, in analyzing the representation and rhetoric of propaganda and power. In an approach that verges on the ethnological, her work gathers together the symptoms of our society and relates them to one another in different ways, depending on their context and the current memory of the event. When Meckseper chronicles political phenomena as protection against forgetting and repression, her work depends on the memory of historical circumstances. More importantly though, she invites society to actively confront and question these circumstances.

Her latest works address the wars that are being waged in strategically important countries in the name of America's national interests. Meckseper isolates the life-sized oil rigs in *Untitled (Oil Rig No. 1)* (2009) and *Untitled (Oil Rig No. 2)* (2009) from their original context by transposing these symbols of the American economy, which has historically been largely based on oil, into an exhibition setting. She contrasts these icons of industrial power, mobility, progress, freedom and independence with the replica of a WWII bunker, *Untitled (Bunker)* (2009), echoing the bunkers photographed and described by Paul Virilio in his book *Bunker Archeology* (1975). Meckseper's interest here lies in creating links between US interests in crude oil, the enormous dependence of the automobile industry on this fossil fuel, and the wars being waged in the Middle East. This she does most compellingly in her video compilation of car commercials, accompanied by a haunting industrial-noise soundtrack by Boyd Rice with the lyrics "Do you want—total war!" In the video *0% Down* (2008), she deconstructs the evocative visual language of the advertising strategists. Flanked by military jets, the design of the car driving through the desert recalls aerospace engineering. Progress, invulnerability and a fascination with all things military are equated with a strong-willed, bellicose nation in the violence-affirming aesthetic of a country engaged in war. The car commercials elicit a fantasy of strength, power and hegemony. In neoconservative American ideology, every individual lays claim to this power—a mindset that is evident in the way the commercial footage suggests that the spectator has freedom of choice in selecting the right car. This work marks a high point in Meckseper's correlation of economic, political and military contexts.

If we take Chomsky's critique seriously, Meckseper's works, such as *0% Down,* can be seen as an overt engagement with the phenomenon that Chomsky described in early 2000 as "media control."[2] He was referring to a subtle form of manipulation, through

which the American mass media creates homogeneity by establishing certain ideas in the collective consciousness. According to Chomsky, this is tantamount to media dictatorship, so that even in free democracies the people are subjected to massive manipulation by the media. One of Chomsky's main accusations against the media is their dissemination of advertising messages, which he describes as "transnational corporate tyranny."[3] In other words, the primary function of the media has been reduced to selling advertisers to an uncritical audience: "They [advertisers] are not going to pay for a discussion that encourages people to participate democratically and undermine corporate power."[4] In an interview, fellow artist Liam Gillick lauds her work *0% Down* as "one of the most elegant and cutting corruptions of contemporary culture I have seen."[5] Gillick makes reference to Chomsky's idea of media control, which maintains that flooding the information channels with specific content is an almost perfect method of manipulation through the media. The constant repetition of images and texts makes them established and rarely questioned truths.[6] In this respect, the persuasiveness of advertising has proved stronger than the influence of news reports. Chomsky outlines how news reports are structured by capitalist mass media in a way that protects the interests of the government and the upper classes. For, according to Chomsky, it is not about winning over the broader public, but about reaching the opinion leaders. In the longer term, business and media corporations benefit from government-friendly reporting. This could also be described as deliberate manipulation of public discourse, in that the discourse, though not specifically forbidden, is subtly controlled.[7]

The current economic crisis is threatening one of the major US industries: many long-established car manufacturers are facing bankruptcy. Advertising becomes a farce that merely underlines the decline of an empire. This is the subject of Meckseper's *Fall of the Empire* (2008), embodied by a darkened showcase with a Hummer advert, a toilet rug with a silver sculpture of an angel and a cellophane-wrapped shop mannequin's head. The title itself, a clear reference to the fall of the Roman Empire, points to the increasing degeneration of Western consumerist culture. Even the once-persuasive car adverts that Meckseper mounted on canvas in another series of works now seem merely irrelevant. Her collages such as *Dodge Viper, Honda NSX GT* or *Ford Mustang* use found advertising posters for prestigious car models. The canvases, wrapped in transparent and pink packaging film, look as though they have come straight from the depot. Nothing is manually produced here—neither the canvases nor the packaging. Industrial goods become art. Meckseper takes a similar approach in *Negative Horizon* (2008), in which a mirror platform and six highly polished chrome wheel rims show the absurd fetish character of a display. The rims become a sublimated status symbol of social surplus and thus lose their original functional character.

A discussion of Meckseper's politically charged works is bound to invite comparison with Chomsky's theories. After all, when it comes to political issues, Chomsky was, for many years, one of the most frequently cited intellectuals, respected for his anti-globalization stance and, as such, a forerunner of the current protest movement. Both Meckseper and Chomsky have a polarizing effect in that they use simple visual and textual language to address thorny political issues and pinpoint current affairs. Chomsky's sympathy for anarcho-syndicalism had its heyday in Europe between 1880 and 1930, which explains the radical tone of many of his statements. The main aim of this movement was the revolutionary overthrow of the state and capitalist society to create a classless, stateless collective. Although we expect a radical stance from an anarchist sympathizer like Chomsky, he actually speaks for a large number of critical, thinking US citizens. His views are undeniably rooted in the ideological dogmatism that emerged in the Cold War era. For instance, when he accuses the US of state terrorism in its subjugation of Iraq or Afghanistan, it is easy to accuse him of painting an all too black-and-white picture. While this may attract criticism, it is also welcomed as a necessary counterbalance to state power.

[3]
Media and Globalization. An Interview with Noam Chomsky, Third World Network, July 1st, 1996: http://www.corpwatch.org/article.php?id=1809.

[4]
Media and Globalization. An Interview with Noam Chomsky, Third World Network, July 1st, 1996: http://www.corpwatch.org/article.php?id=1809.

[5]
Liam Gillick in conversation with Josephine Meckseper: www.interviewmagazine.com/art/josephine-meckseper.

[6]
Noam Chomsky, *Media Control* (see note 2).

[7]
See Noam Chomsky, *Profit Over People: neoliberalism and global order*: Seven Stories Press, New York 1999.

Having grown up in a politically active environment whose views she embraced, Meckseper is perfectly familiar with the dogmatic politics of the 1960s and 1970s. For her, clear-cut or even exaggerated portrayals are a means of maintaining a degree of distanced detachment from the facts. Her *Untitled (Black and White Wall)* and *Untitled (American Flag)* of 2008, in which she abstracts the US American flag, are metaphors for the black-and-white thinking and simplistic friend-or-foe mindset of the US. She also uses showcases and raised platforms not only as a reference to the semantics of department store display techniques, but also, as in *Ten High* (2008) and *Thank a Vet* (2008), as a way of stepping back from a topic to get a more detached view. A very simple work, such as *President's Day* (2007), illustrates her aesthetic approach. Here, Meckseper explores the organizational principle of newspaper layouts, and the design of advertising pages and editorial texts in magazines. In this work, the artist divides the canvas into fields of varying sizes, separated by white stripes, to demonstrate the relationship between the two elements. The abstraction appears like a classic Constructivist painting and serves to neutralize the contrasting worlds of symbols in the media—in newspapers such as the *New York Times*, for instance, an article about victims of the war in Iraq is placed right next to an advert for luxury goods. Meckseper, however, is not interested in the way such disparate themes are given a level playing field in the media. She is more interested in the breadth and scope of capitalist symptoms in general, and their unquestioned acceptance by society. This approach has informed her work since the 1990s, when she edited a fanzine named *FAT*.

Another important social symptom, for Meckseper, is the issue of freedom of expression, which was severely curtailed by censorship under the presidency of George W. Bush, especially after September 11, 2001. In her video *March for Peace, Justice and Democracy, 04/29/06, New York City* (2007), she documented one of the few permitted demonstrations in New York in 2007. Demonstrations were often refused permission, and even newspapers such as the *New York Times* were uncritical of events in Iraq or Afghanistan. The soundtrack to the video has echoes of brainwashing with the repeated, monotonous call: "You shall hear nothing—You shall see nothing—You shall think nothing—You shall be nothing."

Symbols of political protest, such as placards or Meckseper's photographs of demonstrations, are combined in her work with readily available consumer goods. The shop window installation *Verbraucherzentrale* (2007) juxtaposes photographs of demonstrations in the US and Germany, comparing the political culture in the two countries. The showcase also contains several everyday items representing goods tested by the "Verbraucherzentrale"—a German consumer support organization. In these two works, Meckseper takes her cue from Chomsky's aim to promote self-organization in the tradition of anarcho-syndicalism, which includes taking the initiative and seeing events from an objective and critical viewpoint. This demands a certain confidence in questioning the media and the symbols and metaphors of our time. Published information and subjective impressions should be questioned in equal measure. It is well known that the mass media can have an enormous influence on everyday perceptions. Meckseper aims to break this cycle. In this context, it is worth bearing mind Chomsky's famous dictum: "Being an intellectual is a calling for everyone. It means using your own intelligence to advance matters important for humanity."[8]

[8]
Some of Chomsky's most important and influential writings were collated in an anthology published to coincide with his 80th birthday: Noam Chomsky, *The Essential Chomsky,* ed. Anthony Arnove: New Press, New York 2007.

Rachel Hooper

Now, Let the Storm Break Loose

[1]
"Josephine Meckseper in
Conversation with Simone
Schimpf,"
in Marion Ackerman (ed.),
Josephine Meckseper, Hatje Cantz
Verlag, Ostfildern, Germany 2007,
p. 30.

Since the Bush administration first began arguing for an invasion of Iraq, Josephine Meckseper has been recording the massive demonstrations that sprang up in protest. She positioned herself as an observer of street activism with her 2002 photographic series *Berlin Demonstration* and subsequent films, such as *Rest in Peace* (2004) and *March for Peace, Justice and Democracy, 04/29/06, New York City* (2007), shot mostly on 16mm and Super 8 film. Recalling archival footage of the far more publicized anti-Vietnam War protests, these films question "the arbitrariness and entertainment character of news coverage."[1]

Meckseper's subversive critique of how politics play out in the public sphere has evolved over time from a documentary approach with a certain analytical distance into a much more direct examination of commercial interests in the war in Iraq. Her video *0% Down* (2008) is a montage of various car advertisements that saturated the US airwaves in early 2008, set to the song "Total War" written by industrial musician Boyd Rice and recorded under his alias NON in 1997. In what Liam Gillick calls "inverted propaganda," the work reveals the violence latent in the appropriated, otherwise appealing television spots.[2]

Josephine Meckseper's work is informed by a Marxist analysis of how capitalism dictates an inequitable imbalance of power down to the very form of commercial products. The artist says: "The basic foundation of my work is a critique of capitalism. [...] [My works] embody a form of commodity presentation."[3] This echoes Jean Baudrillard, who argued: "Art [...] confronted in modern times with the challenge of the commodity, does not, nor should it, look for its rescue in a critical denial [...] but rather in outbidding the very formal and fetishized abstraction of commodities [...] becoming more commodity than commodity."[4]

In the case of *0% Down*, Meckseper has gone one step further. The video not only embodies commodity presentation, but also unpacks the commodity form. In his 1867 essay "The Fetishism of the Commodity and Its Secret," Marx observed that a commercial product is not only a useful thing, but "a thing possessing value," and that this value "transforms every product of labor into a social hieroglyphic, [...] for the characteristic which objects of utility have of being values is as much men's social product as is their language."[5] One of the goals of advertising can be framed in Marxist language as to encode products with implied meanings and associations that then seem mysteriously to emanate from them as commodities. Concealment of anything other than the values and powers associated with a commodity is at the heart of commodity fetishism. The very design of a product is a mirror reflecting its meanings and desires but concealing the power structure implicit in its fabrication.[6] Through the car commercials, Meckseper turns the fetishization of the car in on itself.[7] At first drawing the viewer in with its slick appeal, the montage slowly dissolves any pleasant and coherent illusions linked to the values these car commercials espouse.

When *0% Down* debuted, the commercials were still playing on television, and to see something familiar so radically unmasked was quite shocking. The original advertisements encouraged us not only to buy cars and trucks, but also to embrace what they had come to stand for: speed, power, luxury, and aggressive exploration. Simply removing the color and sound from these commercials made their images dramatically stark. What they show is control in the face of danger—cars navigating challenging landscapes as their drivers operate them with ease while jets gracefully whisk through the air.

The video opens with a low syncopated banging. The beat is soon joined by the looped, high-pitched drone of a siren that sounds like an engine revving. Fade in on a harshly lit, barren landscape.[8] An SUV speeds toward us, barely outrunning a huge dark cloud that looms over the horizon. A quick series of jump cuts orbit the car, revealing that the SUV is a Nissan Murano, and as the hovering mass overhead gets closer, we realize it is composed of floating homes that swoop down under the automobile's wheels to form a perfect suburban neighborhood as the baritone voice kicks in: "Do you *want* total war? Throw out *Christ* and bring back Thor? Do you *want* total war? Unleash the *beast* in man once more? Do you *want* total war? Dance and do the lion's roar? Do you *want* total war? *Do you want* total war? *Yes*, you want total war! *Yes*, you want total war."

While the industrial anthem plays, the monochromatic montage of car commercials continues. Fighter jets zoom by and morph into Saabs. Giant I-beams swing like pendulums and narrowly miss pickup trucks underneath. Sports cars mutate into splashes of oil and zoom through blurs of stripes. Trucks and SUVs race through mountains, alongside water, and over salt flats. Dispatches flash by detailing their features, price, and slogans. A Nissan Rogue maneuvers through a maze of city streets, narrowly evading holes as if

[2]
Liam Gillick, "Josephine Meckseper," in *Andy Warhol's Interview*, November 2008, p. 48–49.

[3]
"Josephine Meckseper in Conversation with Simone Schimpf," op.cit, p. 27.

[4]
Jean Baudrillard, *Fatal Strategies*, Pluto Press, London 1999, p. 117.

[5]
Karl Marx, "The Fetishism of the Commodity and Its Secret," in Juliet B. Schor and Douglas B. Holt (ed.) *The Consumer Society Reader*, The New Press, New York 2000, p. 333–334.

[6]
See also Diedrich Diederichsen, *On (Surpulus) Value in Art*, Die Keure, Bruges 2008.

[7]
Meckseper's work *United States of America* (2008) shows early ideas for *0% Down*. A row of pictures of football games, hamburgers, sex, and cars is surrounded with aggressive and jingoistic imagery, evidence that the artist was studying American icons in general before deciding on the automobile specifically.

[8]
Meckseper chose this scene because it looks like a piece of urban America transplanted into the Iraqi desert.

in a giant, tilting, labyrinth. Finally, a Hyundai drifts through a dark landscape. Fade to black. Then the logo and tag line—"Think about it."

The adrenaline rush of the fast-paced video with its exhilarating soundtrack amplifies the messages of empowerment and conquest being promoted in the commercials. With their color removed, the advertisements are no longer fantasies, but more like newsreels broadcasting terms of the military's hegemony. The artist says of *0% Down*: "If it had a script, the only line would be: 'Illustrate the obvious ties between the car industry and wars fought over oil.'"[9] The ties between the US Department of Defense and the automotive industry are even more literal than its ties to disputed oil. Of the parent companies of the cars that appear in *0% Down*—Toyota, General Motors (Cadillac, Chevrolet, and Saab), Ford, Nissan, Hyundai, Daimler AG (Mercedes-Benz), Mazda, and Tata (Jaguar)—all but Tata had manufacturing contracts with the US Defense Department between 2002 and 2007.[10] Meckseper could have simply shown copies of these contracts if she wanted to make a concrete argument for how automobile manufacturers are part of the military-industrial complex. Or she could have pointed to how the car industry subscribes to a militaristic image by appropriating the forms of military vehicles such as the Jeep and Humvee to create SUVs.

But these approaches would lack the feeling of catharsis that comes at the end of the video, the sense of a repressed illogical violence suddenly rising to consciousness and being released. Essential to this catharsis is the song "Total War," which directly addresses the ads' subliminal brutality. The term *total war* was coined by the German World War I General, Erich Friedrich Wilhelm von Ludendorff, to describe his ambition for an omnipotent military force. It was once again associated with German warfare during World War II, particularly the way in which under Adolf Hitler "military means were fatally detached from the political ends they served."[11] Total war is thus defined as a war "in which the whole population and all the resources of the combatants are committed to complete victory and thus become legitimate military targets."[12] The term was most famously employed by that master of propaganda Joseph Goebbels, who on 18 February 1943, worked a large audience into a frenzy, asking: "Do you want total war? If necessary, do you want a war more total and radical than anything that we can even imagine today?"[13]

Total war defines what Giorgio Agamben calls the "state of exception," in which executive legislation overrides constitutional rights, and the Geneva Conventions are not applicable to a population whose members are treated more like detainees than citizens.[14] Recent events have shown us that the practice of total war is prevailing. George W. Bush said in his 2002 State of the Union Address that we should pursue terrorists with total disregard for boundaries: "These enemies view the entire world as a battlefield, and we must pursue them wherever they are."[15] It is no surprise, then, that the US military has been accused of mounting indiscriminate attacks in Iraq and Afghanistan. Human Rights Watch and others have criticized US strategy in Afghanistan, in particular, for failing to take the necessary precautions to avoid harming civilians.[16]

But beyond intimating criticism of the reckless use of military power, *0% Down* takes direct aim at the mutual interests of US car manufacturers and the US occupation forces in Iraq to keep the oil flowing. In *0% Down*, what we hear emphasizes what we only unconsciously see—that these car commercials are asking us not only to buy into the security and luxury associated with car ownership, but also into the militaristic aggression that supports that stability. We require automobiles to sustain our lifestyle, and cars require oil, so oil is a commodity that must be aggressively pursued. Perpetual war for perpetual peace.

The assumption that peace is contingent on dominance harks back to the age-old conflict between violence and social integrity that Sigmund Freud examined in *Civilization and Its Discontents*. In his treatise, Freud outlined the conflict between our ego and our need to form a community. Aggression, although inherent in the human condition, dis-

[9]
Liam Gillick,
"Josephine Meckseper," op.cit,
p. 48–49.

[10]
See http://www.
governmentcontractswon.com/
search.asp?type=dc (accessed
January 30, 2009).

[11]
Hugh Bicheno, "Total War," in
*Oxford Companion to Military
History*, Oxford University Press,
Oxford, 2001, 2004. Available at:
http://www.answers.com/topic/
total-war
(accessed January 30, 2009).

[12]
Ibid.

[13]
Joseph Goebbels,
"Nation, Rise Up, and Let the Storm
Break Loose,"
trans. Randall Bytwerk, German
Propaganda Archive, originally
"Nun, Volk steh auf, und Sturm
brich los! Rede im Berliner
Sportpalast," in *Der steile Aufstieg*,
Zentralverlag der NSDAP, Munich
1944. Available at:
http://www.calvin.edu/academic/
cas/gpa/goeb36.htm
(accessed January 30, 2009).

[14]
Giorgio Agamben,
State of Exception, University of
Chicago Press, Chicago 2005.

[15]
Text of President Bush's 2002 State
of the Union Address, January 29,
2002, Courtesy eMediaMillWorks,
Available at: http://www.washing-
tonpost.com/wp-srv/onpolitics/tran-
scripts/sou012902.htm
(accessed January 30, 2009).

[16]
Human Rights Watch,
"The Human Cost:
The Consequences of Insurgent
Attacks in Afghanistan,"
15 April 2007.

turbs our relationships with others, and therefore must be repressed by society if communities are to survive.[17] Karl Marx recognized that this repression impacts the way society, and particularly material culture, functions. As Marx in *Das Kapital* famously said of exchange relations, "They do not know it, but they do it."[18]

This is the very conflict in which Meckseper is embroiled.[19] Her sculptural displays exaggerate the effect of idly leafing through a magazine where "you'll find horror stories from Iraq appearing side by side with underwear adverts."[20] In *0% Down*, she has gone beyond those casual juxtapositions to reflect the conflict hidden within the commercials themselves, between the slick veneer of advertising and the violence of the surrounding culture of consumerism.

This tension is relevant even now, as the world has changed substantially since *0% Down* debuted. Government policies on the Iraq War and the US economy are in flux after the election of President Barack Obama, and automakers became even more entangled in US politics as the outgoing Bush administration gave the "big three"—Ford, GM, and Chrysler—access to the $700 billion in financial rescue funds overseen by the US Treasury. As a result of this bailout, US car companies can no longer afford to run as many commercials, and when they do, the advertisements often tout the cars' efficient gas mileage or smaller, less expensive models.

Yet, the video continues to hold us accountable, for it reflects more than a singular historical/political situation. The tension between aggression and civilization that manifests itself in the video springs from a conflict hardwired into our nature. At this moment, Meckseper's video is directed at our complicity in the Iraq War. But it speaks to the larger destructive forces we are endorsing through our insatiable consumerism and the values it promotes.

[17]
Sigmund Freud, *Civilization and Its Discontents*, trans. James Strachey, W.W. Norton, New York and London 1989.

[18]
"Sie wissen das nicht, aber sie tun es." Karl Marx und Friedrich Engels, "Das Kapital", in: Werke. Karl Marx, Friedrich Engels: Dietz, Berlin 1969, p. 88 [Marx, Engels, Das Kapital. Der Produktionsprocess des Kapitals, 1867] Available at: http://www.mlwerke.de/me/me23/me23_049.htm#M27 (accessed February 4, 2009).

[19]
As Herbert Marcuse has stated, "Reality today is in open and total conflict with its own ideology and with its own promises." "The Containment of Social Change in Industrial Society," in *Towards a Critical Theory of Society*, Douglas Kellner (ed.), Routledge, London 2001, p. 93. Marcuse's Freudian-Marxism has informed my interpretation of *0% Down*, as has Slavoj Žižek's and the Frankfurt School's thinking, especially Slavoj Žižek, *The Sublime Object of Ideology*, Verso, New York 1989, and Theodor W. Adorno, "How to Look at Television," in *The Culture Industry: Selected Essays on Mass Culture*, Routledge, London 1991.

[20] Gillick, "Josephine Meckseper," op.cit, p. 49.

I am grateful to Claudia Schmuckli, Katy Lopez, and Jonathan Leach, whose insights on early drafts of this essay helped me get my thoughts in focus. I would also like to thank Polly Koch for editing the English version, as well as Josephine Meckseper and Arianna Petrich for their careful editing.

Sylvère Lotringer

CRASHING

I

Josephine Meckseper's sculptures and mixed-media installations are especially striking in the spacious site of the migros museum für gegenwartskunst, which is situated in a former beer brewery, an industrial context that reinforces the impact of what is by far the most direct and politically explicit exhibition that Meckseper has ever made. It is not every day that history is knocking at the door, and she may have decided to make a definite statement about an era that is fast disappearing, leaving aside the subtle and unsettling approach to contemporary society that has become her signature. Conceived just a few months before the global financial meltdown and the staggering collapse of the Big Three, the exhibition projects the intensity of the present, when capitalism seems to be unraveling under our very eyes, wrecking havoc across the entire planet, revealing in the process the intricate web of connections between speculative finance, politics, economy and war. In this respect the exhibition anticipates the end of American dominance as it has existed until now, and the resounding demise of the free-market model of capitalism the United States had tried to impose worldwide. The catch phrase of Charles Wilson, head of General Motors under President Dwight D. Eisenhower immediately comes to mind. As he was being confirmed as secretary of defense, Wilson was asked if there was not any conflict of interest, and he famously answered: "As General Motors goes, so goes the nation." This statement has never rung truer than it does today.

The crash of General Motors, a global powerhouse company, and the most symbolic of them all, throws an uncanny light on the Great Car Culture that was part of American power and a major incentive for controlling oil fields worldwide by all means necessary, including the devastating oil war waged in Iraq. Meckseper's exhibition invites us to look back on this still ongoing imperialist saga not just in economic terms, but anthropologically: in times to come, cars, like dinosaurs, like America itself, will be relegated to the National History Museum. This is what the neat canvas posters of cars wrapped up in plastic also tend to suggest. Discarded consumer products, even when glamorized by publicity, are just like body bags. Violence and death are still lurking around, although carefully kept under wraps.

What is being questioned at this point is not just the simulationist aspects of financialized capitalism, but the technology it relies on in order to further its goals. Paul Virilio has reminded us that technology is an enigma that can only be addressed properly by bringing out its *negative* sides, all too often ignored, or considered extrinsic to the invention. Each invention casts a long shadow: car accidents are as much of an invention as the car itself was. Plane crashes are not just a freak occurrence, but a creation in their own right. What is unheard of is not that cars would crash, but that the carmakers themselves would. Accidents reveal the essence of the machine, or of the system. "Integral accidents" that affect the entire planet, such as the one we're experiencing right now, tell us something about the nature of "techno-capitalism."

Virilio helped dispel the humanistic discourse on technology, which usually casts it in instrumental and anthropological terms, as if technology was mere "applied science" manufacturing objects meant to enhance human life, and cars were just made for consumers' convenience and vanity. Heidegger reminded us that the *essence of techne* does not reside in the making itself, rather in the fulfillment of an underlying project or scheme. Technology is not neutral, and its project remains to be spelled out. It is part of a "total war" of which the current wars in Iraq and in Afganistan are just the most visible pointers.

Joseph Goebbels used the expression "total war" in his famous speech of February 18, 1943, in which he exhorted the German people to fight to the bitter end after the collapse of the Eastern Front. The ominous bunker from Virilio's *Bunker Archeology* is a reminder of the time when the space of war crossed Europe from North to South, from the Siegfried Line to the Maginot Line and the Atlantic Wall. "By the same token," Virilio commented, "you touch on the mythic dimension of a war spreading not only throughout Europe, but all over the world." Bunkers, like anti-aircraft shelters, etc., are "reference points or landmarks to the totalitarian nature of war in space and myth."[1]

Total War is not just invoked in extreme situations, it involves the "total mobilization" of populations in time of peace as well as in time of war. Ernst Junger was the first to raise the concept of mobilization in *The Worker* (*Der Arbeiter*, 1938), suggesting that a fixed budget would not be enough to cover the costs of waging a total war. In addition to the armies on the battlefields, the "modern armies of commerce and transport, foodstuffs, the manufacture of armaments—the army of labor in general," should be mobilized.[2] From then on battles would not be waged on the battlefields, but in the "battle of movement." In the same article, Junger pointed out that total mobilization did not mean enlisting people in the army, or sending them to the battlefields, but rather their "readiness" for mobilization.

Virilio has often referred to this concept in his own elaboration of "pure war," a war that would be waged without an actual war being the necessary outcome. The Cold War was its perfect illustration. Although bloody wars were unleashed in various corners of the world (in Korea, Vietnam, Afganistan, etc.) the two adversaries kept "deterring" each other from triggering the fatal outcome, relying instead on economic and technological escalation to achieve similar results. This fusion of science and war signaled the breakdown of the distinction between the civilian and the military. Unlike Virilio, Junger dwelt

[1]
Paul Virilio/Sylvère Lotringer.
Pure War, trans. Mark Polizotti,
Semiotext(e), New York 1983,
1997, p. 10.

[2]
Ernst Junger, "Total Mobilization,"
*The Heidegger Controversy:
A Critical reader*, Richard Wolin
(ed.), The MIT Press, Cambridge,
Mass. 1993, p. 126.

at length upon the sociological implications of this mutation. He defined the "Worker" as a "new reality," even a new human "race" meant to replace both the bourgeois and the proletarian. The army of labor would not be relegated anymore to industrial ghettos, the whole society would become a "total work-space" directly enlisted to the war effort. This new reality, he believed, would be governed by the "Figure" (*gestalt*) of the worker. Junger hailed technology as a demoniacal power bound to destroy all individual differences between classes and nations. But what the Worker lost in individuality, he would gain in precision and objectivity, work becoming the source and destination of every human existence. "The face which looks at the observer under the steel helmet or that of the pilot has also changed [...] It has become more metallic, as if galvanized on the surface, the bone structure jutting out markedly [...]"[3]

[3]
Ernst Junger, *Der Arbeiter*, p. 149.

It was a new *metallic* race that was beginning to develop according to the requirement of a new technological landscape. In Meckseper's exhibit, from the life-size insect-like steel derricks to the chromium plates of cars, and from the abstraction of car rims to the metallic surface of the mannequins' bodies, a new technological race-crossing species is in the making. It encompasses the sleek war-like display of SAAB commercials with jet planes bouncing in the background while the added 1990s industrial music keeps ironically asking: "Do you want total war?"

Junger saw this new humanity as a combat "elite" not defined by its individuality but moved by a "superior legality" to fulfill specific tasks, and even hailed the Kamikaze pilots in Japan in 1934 as a kind of "Nietzschean humanism." The invention of electronic technologies over the last decade has made this elite far less identifiable, actually more of a mass phenomenon. The "extreme coldness" of the metallic features moved inside, but remained no less metallic for all that. Gilles Deleuze called this new race waving cell phones and credit cards as their weapons: "dividuals."

Readily identifiable in dynamic vehicles, the effects of technological violence are no less powerful for remaining unnoticed. In fact, the less explicit the violence, the more far-reaching its impact. Moving from vehicular vectors, outwardly in nature, to more intangible weapons of communication—visual technology like photography, film, television and video, up to the most recent advances in electronic media technologies, all indirect offshoots of military research and "Star Wars" type technological deterrence—this technology is quickly approaching the absolute value of the speed of light, waging another kind of war on the human environment. The "real-time" of telecommunication is abolishing the distinction between the real and pictures we derive from it, substituting for the actual physical proximity a more virtual kind of presence. This "transparence" is the ultimate accident generated by the "vision machines" in which the speed of images has replaced actual physical movement. Instantaneity and ubiquity are now canceling memory and history, triggering a general de-realization of reality. Modern technology has drastically changed our relation to the world, which can only be grasped, in Heidegger's formula, as a "word-picture." The advent of "instant time" on a global scale announces the virtual disappearance of the social. The technology of warfare and the techniques of perception have become one.

II

Paul Virilio
The Total Accident
An Interview with Sylvère Lotringer

Sylvère Lotringer: *We're running out of time. Everything now is happening in real time, except that time seems to have lost its reality. And this is also true for history.*

Paul Virilio: We no longer participate in the trilogy past-present-future. Today we are experiencing an acceleration not only of History, but also of the instant. The instant isn't present. The instant of the immediacy and of the ubiquitousness doesn't participate in the present. It has acquired its accidental autonomy.

In the past, historians from the Annales School studying archives dealt with two historical categories: the long Braudelian periods—Braudel, March Bloch, Lucien Febvre were concerned with general history (centuries and civilizations) and the history of the events (1914–1918, the French Revolution, the Russian Revolution). Now, a new element originating in instantaneity is inscribing itself in history. We still have long durations, we still have the time frame of certain events that participate in the present (the present of the 1789 Revolution, the present of the Russian Revolution, etc.), but we're entering the possibility of an accidental History, of a history that connects neither in the past, nor in the present, nor in the future. History as event has been replaced by an accidental history with no points of reference. In this sense, it is an accident of time.

The Unsurpassable Success

Globalization is turning into a disaster. The planet is shrinking and we are also running out of space. We're on top of each other on both counts. A simple flap of the butterfly's wings and the entire globe goes haywire. Should we de-globalize ourselves and get out of this disastrous situation?

Hence all these studies on the exo-planet, the exo-biologists, what I would call the exo-science. In other words, we are now re-launching the colonial enterprise into the *outer world*. Cyberspace is already a colony that replaces the real world. The sixth, virtual continent already is a sort of new colony, a preparation for the immigration to outer space. Through the search for exo-planets, by means of space probes, etc. there is something that takes us, not to the other world—say, the discovery of America—but to the *outer* world.

An integral accident on the planetary scale would be capable of incorporating a whole host of incidents and disasters in a chain reaction. Is that also what we can detect in the trajectory of disaster?

No, the trajectory of disaster is the accident's development. The accident has become inseparable from progress. Hannah Arendt explained this when she said, "The catastrophe and the accident, the two sides of the same coin." The more progress unfolds, the more insurmountable catastrophe is. Now, since the end of the 20th century, we have entered the era of an unsurpassable success: the world is too small for progress.

It has succeeded all too well.

It has succeeded too well, and has closed itself off, foreclosed, enclosed onto itself; this explains people's temptation to enclose themselves within gated communities or towers that repeat Babel's myth, which, in a certain way, will develop catastrophe's principle. Catastrophe is a sort of knowledge that one doesn't acknowledge, except in technological crashes. And this is my point: future universities will study the catastrophe of progress. Every area of knowledge is summoned to participate in the barbarity of techno-scientific progress. In the same way that European universities were created in Bologna, at the Sorbonne and later in Salamanca around barbarity—History's barbarity—we have to re-invent, not in the year 1000, but in 2000, a university that opposes catastrophe and the catastrophic success of techno-scientific progress in the areas of atomic knowledge, information technology and genetics, Einstein's three bombs. The atom bomb was made possible by the informational bomb; the informational bomb made the genetic bomb possible—through the mapping of the human genome, the possibility of cloning, even of creating hybrid species, etc. So, in today's universities we have to invent the equivalent of the *crash* test in an enterprise—I want to remind you that a crash test is part of History.

The Financial Accident

Several years ago we talked in some detail about a financial crisis that would trigger the total accident. It would be, you said, the prime example for the book that you are writing on the accident. This integral accident is now happening before our very eyes.

We are up to our neck in it. The *crash* is the model of the total accident. Why? Because, together with war, it is the example of instantaneity. Let me remind you: if time is money, then speed is power, the *power* of money and not just money. So, the new series of crashes—remember the crash in Japan, the mortgage meltdown that completely destabilized Japan, which used to do so well before that—is happening now in the United States, and it will happen everywhere. And this has nothing to do with the 1929 crash.

I just talked about it with an old Italian friend, Christian Marazzi, who is a well-known economist in Switzerland. He told me that he has started studying catastrophe theory because he realizes that we have no way of knowing where all this will lead us. According to him, it will take at least two more years before we know exactly the full extent of the crisis. We have never faced a situation of that kind before, in which the entire financial system could collapse.

Absolutely. In the early 1980s I came up with the idea of a Museum of the Accident, as I called it then. At the time Jack Lang was the [socialist] Minister of Culture in France and François Barré was president of the Centre Pompidou. I was interviewed by *Art Press* on the ruins of the La Villette slaughterhouse and François Barré asked me, "What do you think we should do with these ruins? You are interested in ruins." And I told him, "I would make a Museum of Science and Technology." He told me, "That's exactly what they are planning to do." And I said, "That's perfect." Then he asked, "And what should we

include in the program?" And I told him, "It's clear that each area of knowledge should present its success *and its catastrophe*." There should be no censorship on the nature of the catastrophe arising from the progress in that discipline. Of course, no one asked for my opinion on La Villette—curiously, I was consulted on other occasions, but not on this project. And when did they open the Cité de Science in La Vilette? In 1986. And 1986 was Chernobyl and Challenger. And at that time I made a point of writing another article in *Art Press*: "I remember you interviewed me, and you said once again that the Museum of the Accident is the TV. You, Scientists, proved incapable of facing this question. And since then it has become bigger and bigger; we saw the Space Shuttle Colombia disintegrate, etc."

We have now moved from the nuclear accident and the space accident to the financial accident.

Exactly.

Did you foresee that it was in the offing?

I always believed that the financial accident, the financial *crash* was the model of the integral accident, because it projected at the greatest speed the consequences of the error or of the hyper-quotation. If there is a place where hyper-accidents happen, it is certainly on Wall Street. Every day one accident can trigger others. This is what the market is about.

But this one came from the markets' instantaneity.

In this case too, if time is money, speed is power. This is why we enter a race. What is a race? It means taking hold of power by getting there first. And at the same time we ride on horseback, drive a car, walk on foot. It's very clear that speed = power, and power = speed, and instantaneity, ubiquitousness and immediacy are the prerogatives of the divine.

It's true for speed, but as for power, it's hard to say where it is located at the present time.

Usually, speed allows us see, which is the case with television. During online streaming, the speed of transmission allows us to see what is happening somewhere else. So it's clear that speed is the power of vision. And it should also be the power of pre-vision, of predicting. And that's not the case. But I think this is an extraordinary taboo, I mean the fact that, in the world of progress, no one is free to be rational.

Isn't the world completely irrational at this point?

Yes, but they swear it is reasonable. And this is the great bluff, the three-card monte. Just a word: what I am opposed to is the progress of techno-science, not the progress of science. I object to the instruments produced by science, whatever they may be. Once we start producing instruments, I'd say that they should be subjected to Popper's rule, they should be tested.

You predicted the financial crisis; what do you predict now?

The Crisis of Politics

The crisis of politics. By this I mean that global governing is no longer possible in the context of the state. Why? Because computers, mathematical programs, superior mathematics have been used in economy, and it's obvious that they are incapable of managing global economics. It became obvious with the Kervielle scandal in France, and it is true for everything that's going on in the United States right now. Now when we see politicians and leaders in power throughout the world, whether Sarkozy, to start with, or George W. Bush or Berlusconi or Putin, the list is endless, there isn't a single politician up to the challenge of globalization, of the finitude. In the past when a man said, "I want to be the master of the world," he was locked up. Now, these men have the power to manage the finitude—our finitude is not the Apocalypse, but the closure—and none of them are up to it, it's beyond their capability. And the question of democracy will shortly be raised.

Years ago, we discussed the notion of "transpolitics." Is globalization really making the capacity to act politically impossible?

The capacity to act politically was linked to the past, to historical progress. If democracy exists it's because the Greeks existed. If monarchy existed, etc. So, in some way, political science was linked to the history of government knowledge, whether religious or secular-republican, whether royalist or democratic. But the speeding up of history, which provoked the *blitzkrieg*, that is to say, WWII—don't forget that I am a child of WWII, the lightening-war—has also caused the accident of History. The 20th century, "an unforgiving century," as Camus said, is Auschwitz as well as Hiroshima. So, this time, the speeding up of the real, real time, immediacy, instantaneity, is entirely slipping away from the political. No kind of politics lives up to this quasi-divine event. Managing the world's economy and ecology in real time has become impossible, unless we renew the foundations of politics, as the Greeks did at the origin of History. And then we find again... I rediscovered a book that I liked a lot by a man who is a great teacher for me, Vladimir Jankélévitch, *The Austerity of Moral Life*. It is a book no longer in print, [...] a book more relevant for today's world than we can imagine. What is ecology? It's austerity. It's very clear for me, it's not decadence, it's austerity. No one today is capable of reflecting on the very foundation of ecological austerity, on its gravity and difficulty. Everyone, Sarkozy included, says: "We'll manage, it's nothing serious, don't worry."

Austerity means that less is more.

So, humility is tomorrow's virtue. I'd like to remind you that the expression "humility is truth" is Teresa of Avila. Well, this expression is about to become tomorrow's political truth, unless we reinvent colonialism and move into space to discover a new empire among the other planets, etc. At a time when colonialism—French, British colonial empire—is criticized so harshly, one feels like saying, "And you are now doing the same thing with the other planets! Congratulations!"

What can we expect from politics when people now are merely managing catastrophes? In fact, they totally live up to the catastrophe since they contribute to it.

The catastrophe of progress is the catastrophe of success. It is a paradoxical logic. The problem is not that a nuclear plant might break down; the problem is that we keep building nuclear plants. When a nuclear plant breaks down, even if that involves destruction, it's nothing more than a failure; but to keep building them alleging the exhaustion of natural resources (coal, oil) is another kind of catastrophe. This is not a failure, it is the

success of the proliferation of nuclear plants that is becoming a bigger threat than the depletion of energy resources. And we can very well see that right now nuclear energy is again an idea on the table, in spite of Chernobyl, twenty years after.

Even nuclear war is back in tactical weapons. It's all creeping again through the back door.

Nuclear war, proliferation... We are beyond deterrent weapons. I mean, nuclear deterrence is gone. Proliferation cancels deterrence.

And in catastrophe, what's the place of death, of kamikaze?

I've talked about the suicidal state in one of the chapters of *The Insecurity of Territory*. The suicidal state was a local figure, a figure of a State, of individuals, of social classes that could participate in suicide. We've seen it in Japan during WWII, we see it today in the integral, fundamentalist Islam. We see how the suicidal state can become a State in the political sense of the word.

A Catastrophic State

It would be a catastrophic state. We've seen that before in Nazi Germany. The totalitarian state was a catastrophic state.

I'd like to point out that when the emperor of Japan saw that the war was lost, the Japanese military launched the idea of national suicide—the nation was committing suicide. The Japanese had to oppose the military in order to accept defeat.

And now we are on the verge of an international catastrophe.

Today we are no longer at a national level; we are experiencing a mobilization of kamikazes. But it's already similar; the number of voluntary kamikazes, the suicide in the name of a religion has become a very worrisome phenomenon, an epidemiological phenomenon. In Japan, it was the emperor's project; in today's Islam it is a project that springs out of the social body. It's not a state that orders national suicide; rather, there is a "generosity" of mass suicide. The problem is no longer that of weapons of mass destruction; it is the masses that are destroying themselves, that are self-destructing. The kamikaze is indeed one of the greatest questions, but it comes from Japan.

Don't you think that, on the one hand, this is an individual act, but on the other, it is a collective response? The kamikazes are a response to the kamikaze of our own culture.

Absolutely. The invention of the atomic bomb was a historic and scientific accident. Besides, Oppenheimer said, "Maybe we have sinned"—a scientific sin. He meant that maybe we have gone too far. And, indeed, there was a responsibility of science, which has become mortal. It tied its fate with war and it became mortal.

In some way, the Islamic kamikazes reveal what we haven't seen: that we are in a suicidal state.

It's a mirror effect. The suicidal state existed during WWII, it existed in Germany. Hitler couldn't order a national suicide, but when he died, he ordered the poisoning of

all people and the destruction of all military plants, etc. It was a suicidal logic. And the invention of the atomic weapon was suicidal for science—or rather, for techno-science. Hence, the scientist's words, "We may have sinned"—a scientific sin.

In short, our suicidal tendency comes back to us from the outside. It is revealed to us because it puts us in danger at the same time.

There is no more exterior. This is what globalization means, we are all foreclosed, enclosed. There is a foreclosure of History which matches the world's reduction to the instant. The world used to be big, endless, immeasurable, that's why it was called "world"— it wasn't called "universe," it was called "world." And this world is about to close itself off because of the acceleration in all areas: acceleration of information, acceleration of transportation and acceleration of consequences. I'd like to remind you of Churchill's words, "We have all entered the era of consequences." Winston Churchill said this in 1939, right after Munich, and today we can say this on a global scale, not only merely on a European or WWII scale. We have entered the era of ecological and eco-logistical consequences. I always use the word "eco-logistics." Ecology is the eco-logistics. It is the acceleration of transportation and transmission—instantaneity, ubiquitousness, immediacy. There is a book by Cioran I discovered, *The Evil Demiurge*, a very interesting book in which he has this sentence, the concluding sentence: "We all are all at the bottom of a hell whose every instant is a miracle." The Evil Demiurge is techno-science, and it is its progress that abolishes us.

APPENDIX

Authors' Biographies

Rachel Hooper
Born in 1980. MA in art history from Williams College. Cynthia Woods Mitchell Curatorial Fellow at Blaffer Gallery, the Art Museum of the University of Houston, since 2007. Previously a Curatorial Fellow at the Walker Art Center in Minneapolis.

Gail Kirkpatrick
Born 1952 in Princeton, New Jersey. BA from Wells College New York, 1974; PhD Westfälische Wilhelms-Universität Münster, 1986. Curatorial Assistant at Westfälische Wilhelms-Universität Münster 1986–1991. Director of the Municipal Gallery Am Hawerkamp 1991–2003. Director of Ausstellungshalle zeitgenössische Kunst Münster since 2004.

Sylvère Lotringer
Born 1938 in Paris, lives in Los Angeles and Baja, California. Philosopher, literary critic and cultural theorist. He is best known for synthesizing French theory with American literary, cultural and architectural avant-garde movements through his work with *Semiotext(e)*, and for his interpretations of French theory in a 21st century context. He is Professor Emeritus at the Columbia University, New York.

Heike Munder
Born in 1969. MA in cultural studies from the University of Lüneburg. Director and curator of the migros museum für gegenwartskunst Zürich since 2001. Previously co-founded the Halle für Kunst Lüneburg e.V., which she co-directed from 1995–2001.

Paul Virilio
Born 1932 in Paris. Philosopher, cultural theorist and urbanist. He is best known for his writings about technology as it has developed in relation to speed and power, with diverse references to architecture, the arts, the city and the military. In 1975 he co-organized the *Bunker Archeologie* exhibition at the Centre Georges Pompidou, Paris, a collection of texts and images relating to the Atlantic Wall.

Josephine Meckseper
Born 1964 in Lilienthal
Lives and works in New York

EDUCATION

1990–92
MFA, California Institute of the Arts, Valencia, California
1986–90
Graduate Studies, Hochschule der Künste, Berlin

SOLO EXHIBITIONS
(SELECTION SINCE 2001)

2009
/ migros museum für gegenwartskunst, Zürich
/ Blaffer Gallery, the Art Museum of the University of Houston
/ Ausstellungshalle zeitgenössische Kunst Münster
/ Nottingham Contemporary, Nottingham
/ SculptureCenter, Long Island City

2008
/ New Photography 2008: Josephine Meckseper &
Mikhael Subotzky, MoMA, New York
/ Arndt & Partner, Berlin
/ Elizabeth Dee Gallery, New York
/ Colette, Paris
/ Gesellschaft für Aktuelle Kunst, Bremen

2007
/ Kunstmuseum Stuttgart, Stuttgart
/ Galerie Reinhard Hauff, Stuttgart

2005
/ %, Elizabeth Dee Gallery, New York
/ The Bulletin Board, White Columns, New York

2004
/ IG-Metall und die künstlichen Paradiese des Politischen,
Galerie Reinhard Hauff, Stuttgart

2003
/ Elizabeth Dee Gallery, New York

2001
/ Shine – oder Jedem das Seine, Galerie Reinhard
Hauff, Stuttgart

GROUP EXHIBITIONS (SELECTION SINCE 2003)

2010
/ Contemplating the Void, Solomon R. Guggenheim Museum,
New York

2009
/ 1989. End of History or Beginning of the Future? Comments
on a Paradigm Shift, Kunsthalle Wien, Vienna
/ Shape of Things to Come. New Sculpture, The Saatchi Gallery,
London
/ Extended. Sammlung Landesbank Baden-Württemberg, ZKM,
Karlsruhe
/ FAX, The Drawing Center, New York
/ Bildschön. Schönheitskult in der aktuellen Kunst, Städtische
Galerie, Karlsruhe
/ MAN SON 1969. Vom Schrecken der Situation, Hamburger
Kunsthalle, Hamburg
/ Living Together, Centro Cultural Montehermoso Kulturunea,
Vitoria Álava; Museo de Arte Contemporáneo, Vigo

2008
/ Prospect. 1, New Orleans
/ Shrink-Wrapped, Or Belkin Satellite Gallery, University
of British Columbia, Vancouver
/ Strange Connections. Art und Fashion, Kunst + Projekte,
Sindelfingen
/ Alternating Beats, Museum of Art – Rhode Island School
of Design, Providence
/ Asking we Walk. Voices of Resistance, Den Frie Udstillingsby-
gning, Copenhagen
/ Business As Usual, Museum of Contemporary Art, Detroit
/ That Was Then... This is Now, P.S.1, New York
/ Zidovi na Ulici | Walls in the Street, Museum of Contemporary
Art, Belgrade
/ Common Affairs. Steirischer Herbst, Landesmuseum Joan-
neum, Graz
/ Vertrautes Terrain – Aktuelle Positionen in / über Deutschland,
ZKM, Karlsruhe
/ Sculpture Is..., Arndt & Partner, Berlin

2007
/ Fit to Print. Printed Media in Recent Collage, Gagosian
Gallery, New York
/ Bare Life, The Museum on the Seam, Jerusalem
/ Brave New Worlds, Walker Art Center, Minneapolis
/ From 60 to 7, Henie Onstad Kunstsenter, Hovikodden
/ An Atlas of Events, Calouste Gulbenkian Foundation, Lisbon
/ Shadows in Paradise, FRAC Nord – Pas de Calais, Dunkerque
/ When We Build Let Us Think That We Build Forever, Baltic –
Centre for Contemporary Art, Gateshead
/ New York States of Mind, Haus der Kulturen der Welt, Berlin;
The Queens Museum of Art, Queens
/ Resistance Is, Whitney Museum of American Art, New York
/ Moscow Biennale
/ Just Kick It Till It Breaks, The Kitchen, New York

2006
/ Media Burn, Tate Modern, London
/ Biennial of Contemporary Art Seville
/ Video America, The Hospital Gallery, London
/ USA Today, Royal Academy of Arts, London; The State
Hermitage Museum, St. Petersburg
/ Cooling Out – On the Paradox of Feminism, Lewis Glucksman
Gallery, University College, Cork; Halle für Kunst, Lueneburg;
Kunsthaus Baselland, Basel
/ Trial Balloons, Museo de Arte Contemporaneo de Castilla
y Leon, Leon
/ Whitney Biennial, New York

2005
/ Biennale d'Art Contemporain de Lyon
/ Schwarz Brot Gold. Die Neue Republik, Oldenburger
Kunstverein, Oldenburg
/ Girls on Film, Zwirner & Wirth, New York
/ Bonds of Love, John Connelly Presents, New York
/ A.B.Normal, Nyehaus, New York

2004
/ Heimweh. Young German Art, Haunch of Venison, London
/ The Future Has a Silver Lining. Genealogies of Glamour,
migros museum für gegenwartskunst, Zürich
/ Dresscode, Kunstverein Neuhausen
/ American Idyll, Greene Naftali, New York

2003
/ Fuckin' Trendy, Kunsthalle Nürnberg, Nuremberg
/ All That Glitters, Islip Art Museum, East Islip
/ In the Public Domain, Greene Naftali, New York
/ Nation, Frankfurter Kunstverein, Frankfurt

List of Works

p. 1
Honda NSX GT
2008
Plastic and mixed
media on canvas
183 × 122 cm
Courtesy of the artist
and Arndt & Partner,
Berlin / Zurich

p. 2
Premier (Cross)
2008
Plastic and mixed
media on canvas
183 × 122 cm
Courtesy of the artist
and Arndt & Partner,
Berlin / Zurich

p. 3
Dodge Viper
2008
Plastic and mixed
media on canvas
183 × 122 cm
Courtesy of the artist
and Arndt & Partner,
Berlin / Zurich

p. 4
*Shelby GT500
(Grey, double)*
2008
Plastic and mixed
media on canvas
183 × 122 cm
Courtesy of the artist
and Arndt & Partner,
Berlin / Zurich

p. 6
Shelby GT500 (Black)
2008
Plastic and mixed
media on canvas
183 × 122 cm
Courtesy of the artist
and Arndt & Partner,
Berlin / Zurich

p. 7
Mustang (L)
2008
Plastic and mixed
media on canvas
183 × 122 cm
Courtesy of the artist
and Arndt & Partner,
Berlin / Zurich

p. 8
Shelby GT500 (Grey)
2008
Plastic and mixed
media on canvas
183 × 122 cm
Courtesy of the artist
and Arndt & Partner,
Berlin / Zurich

pp. 40–43
*March for Peace,
Justice and Democracy,
04/29/06, New York
City*
2007
Black-and-white and
color 16mm film trans-
ferred to DVD, sound
7:20 min.
Courtesy of the art-
ist, Arndt & Partner,
Berlin / Zurich and
Galerie Reinhard Hauff,
Stuttgart

p. 73
Untitled (Bunker)
2009
Mixed media
220 × 289 × 289 cm
Courtesy of the artist

pp. 74–75
Exhibition view:
migros museum für
gegenwartskunst
Zürich
Photo: A. Burger,
Zurich

Foreground:
Ten High
2008
Mixed media
350.5 × 350.5 × 440 cm
Courtesy of the artist
and Elizabeth Dee
Gallery, New York

pp. 76–77
Exhibition view:
migros museum für
gegenwartskunst
Zürich
Photo: A. Burger,
Zurich

Foreground:
Ten High
2008

Background:
*Untitled
(American Flag)*
2008
Paint on wall
Dimensions variable
Courtesy of the artist
and Elizabeth Dee
Gallery, New York

p. 78
Exhibition view:
Elizabeth Dee Gallery,
New York
Photo: Jason Schmidt,
New York

Foreground:
Ten High
2008

Background:
Untitled (Miriam)
2008
Mixed media on canvas
101.5 × 76 cm
Courtesy of the artist
and Elizabeth Dee
Gallery, New York

*Untitled
(American Flag)*
2008

pp. 80–81
H3T
2008
Mixed media on canvas
200.5 × 279.5 cm
Courtesy of the artist
and Elizabeth Dee
Gallery, New York

p. 83
President's Day
2007
Acrylic on canvas
200 × 160 cm
Sammlung Landesbank
Baden-Württemberg
Courtesy of Galerie
Reinhard Hauff,
Stuttgart

pp. 84–85
Exhibition view:
migros museum für
gegenwartskunst
Zürich
Photo: A. Burger,
Zurich

Foreground:
Untitled (Bunker)
2009

pp. 86–87
Fall of the Empire
2008
Mixed media
125.5 × 232 × 63.5 cm
Courtesy of the artist
and Arndt & Partner,
Berlin / Zurich
Photo: Bernd
Borchardt, Berlin

pp. 88–89
*Blackwater, No Country
for Old Men*
2008
Digital print on
reflective film mounted
on aluminum
89 × 126.5 cm
Grace Family
Collection, New York
Courtesy of Elizabeth
Dee Gallery, New York

p. 91
Untitled (Oil Rig No. 2)
2009
Paint, iron, wood
Ca. 497 × 132.5 ×
400 cm
Courtesy of the artist
and Galerie Reinhard
Hauff, Stuttgart
Photo: A. Burger,
Zurich

pp. 92–93
Exhibition view:
migros museum für
gegenwartskunst
Zürich
Photo: A. Burger,
Zurich

Foreground:
Thank a Vet
2008
Mixed media
183 × 239.5 × 120 cm
Courtesy of the artist
and Arndt & Partner,
Berlin / Zurich

p. 95
Thank a Vet
2008

pp. 96–97
Exhibition view:
migros museum für
gegenwartskunst
Zürich
Photo: A. Burger,
Zurich

Foreground:
Negative Horizon
2008
Chrome rims, mirrors
129 × 239.5 × 120 cm
Courtesy of the artist
and Arndt & Partner,
Berlin / Zurich

pp. 98–99
0% Down
2008
1 channel video
projection (black-
and-white, sound)
6 min.
Courtesy of the artist,
Arndt & Partner,
Berlin / Zurich and
Elizabeth Dee
Gallery, New York

pp. 100–101
Exhibition view:
Arndt & Partner, Berlin
Photo: Bernd
Borchardt, Berlin

Background:
0% Down
2008

pp. 102–103
Exhibition view:
migros museum für
gegenwartskunst
Zürich
Photo: A. Burger,
Zurich

Foreground:
Verbraucherzentrale
2007
Mixed media
139.5 × 399.5 × 51 cm
Courtesy of the artist
and Galerie Reinhard
Hauff, Stuttgart

pp. 104–105
Verbraucherzentrale
2007
Photo: A. Burger,
Zurich

pp. 106–107
Exhibition view:
migros museum für
gegenwartskunst
Zürich
Photo: A. Burger,
Zurich

Left projection:
*March for Peace,
Justice and Democracy,
04/29/06, New York
City*
2007

Right projection:
Mall of America
2009
1 channel video
projection (high
definition video
transferred to DVD,
color, sound)
12:51 min.
Courtesy of the artist
and Galerie Reinhard
Hauff, Stuttgart

pp. 108–109
Mall of America
2009

pp. 110–111
Save a Bundle
2007
Mixed media
165.1 × 261 × 61 cm
Courtesy of the artist,
Elizabeth Dee Gallery,
New York and Arndt &
Partner, Berlin / Zurich
Photo: Bernd
Borchardt, Berlin

p. 112
Unable Bodies
2008
Mixed media
61 × 101.5 × 38 cm

Courtesy of the artist
and Arndt & Partner,
Berlin / Zurich
Photo: Bernd
Borchardt, Berlin

Untitled (Bunker)
2009

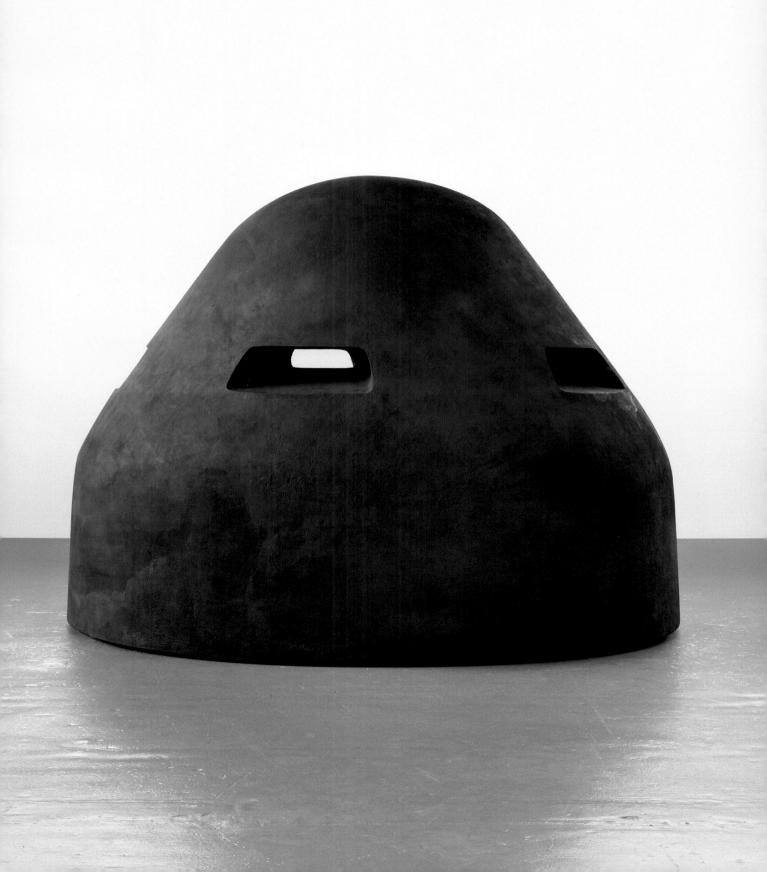

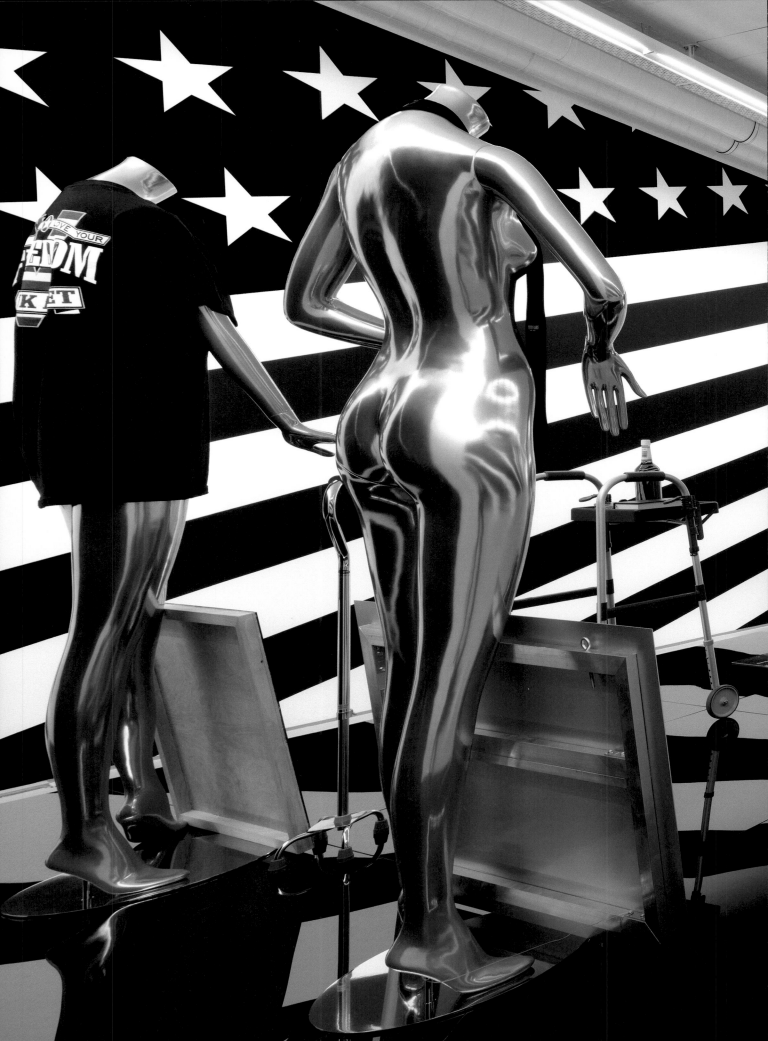

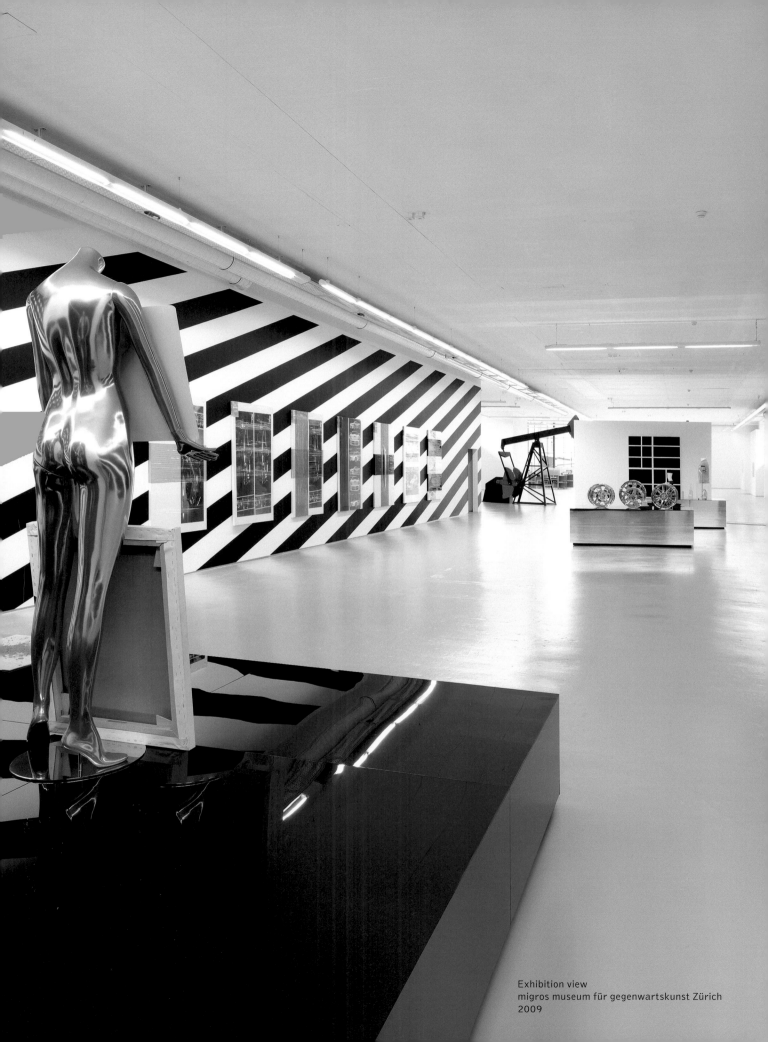

Exhibition view
migros museum für gegenwartskunst Zürich
2009

GOING OUT
OF BUSINESS
SALE

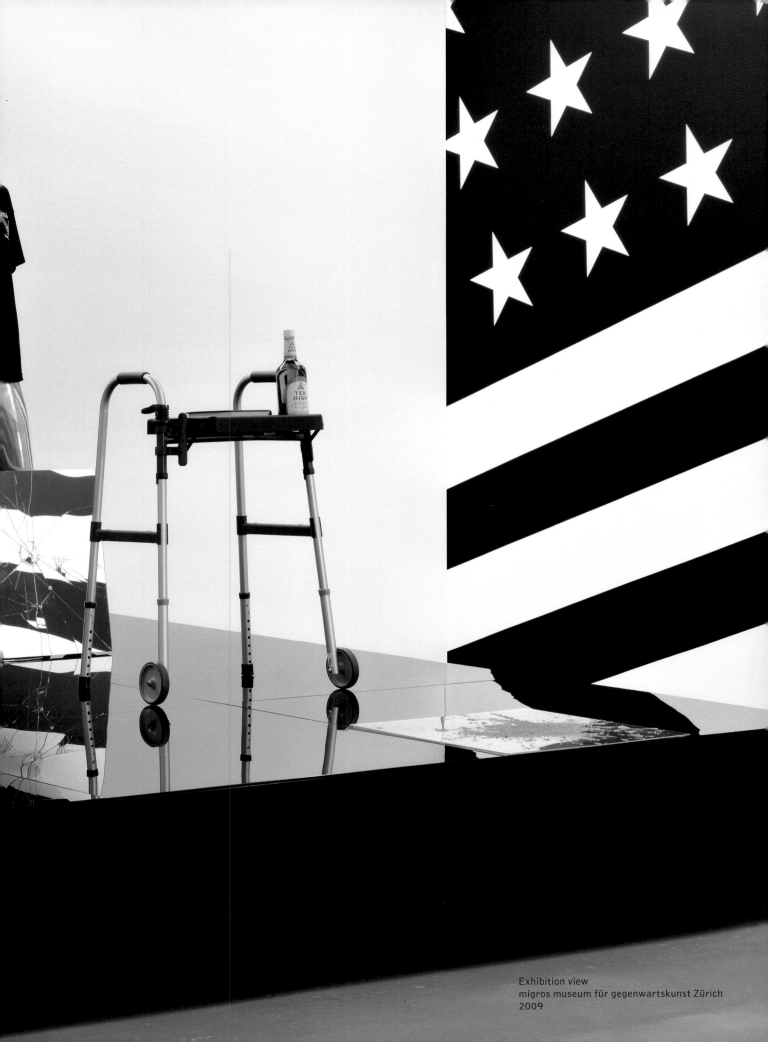

Exhibition view
migros museum für gegenwartskunst Zürich
2009

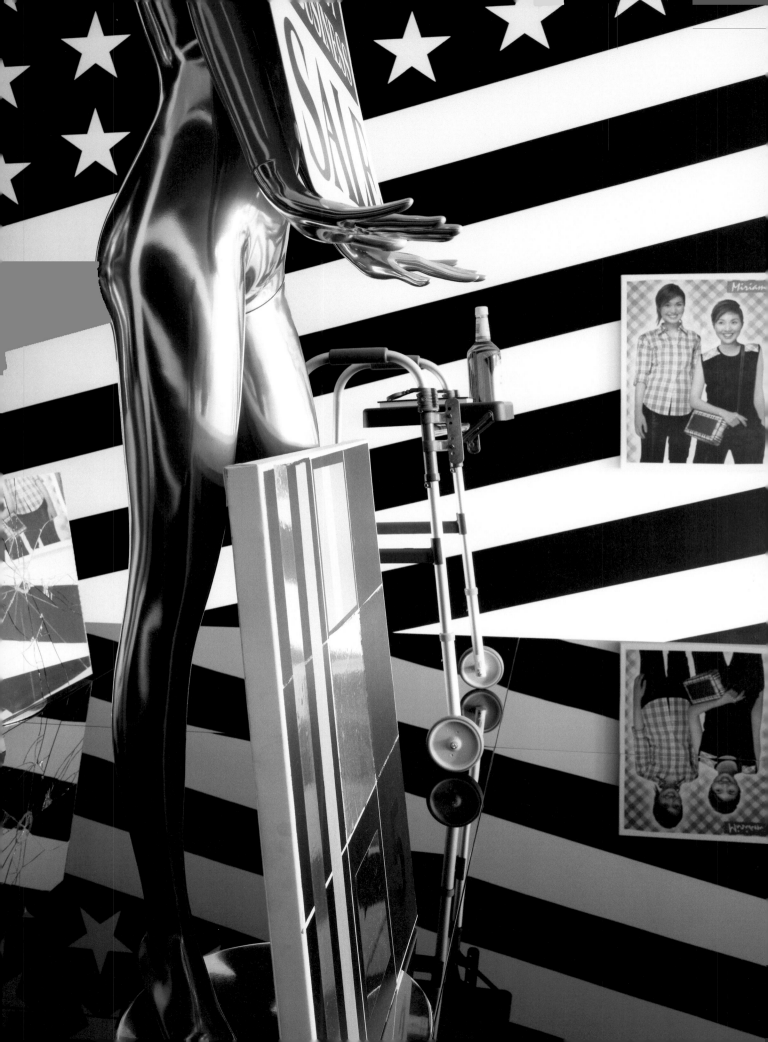

Exhibition view
Elizabeth Dee, New York
2008

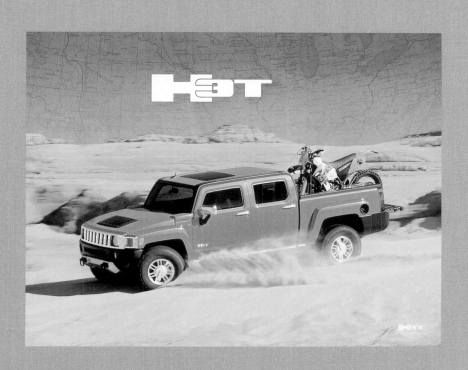

President's Day
2007

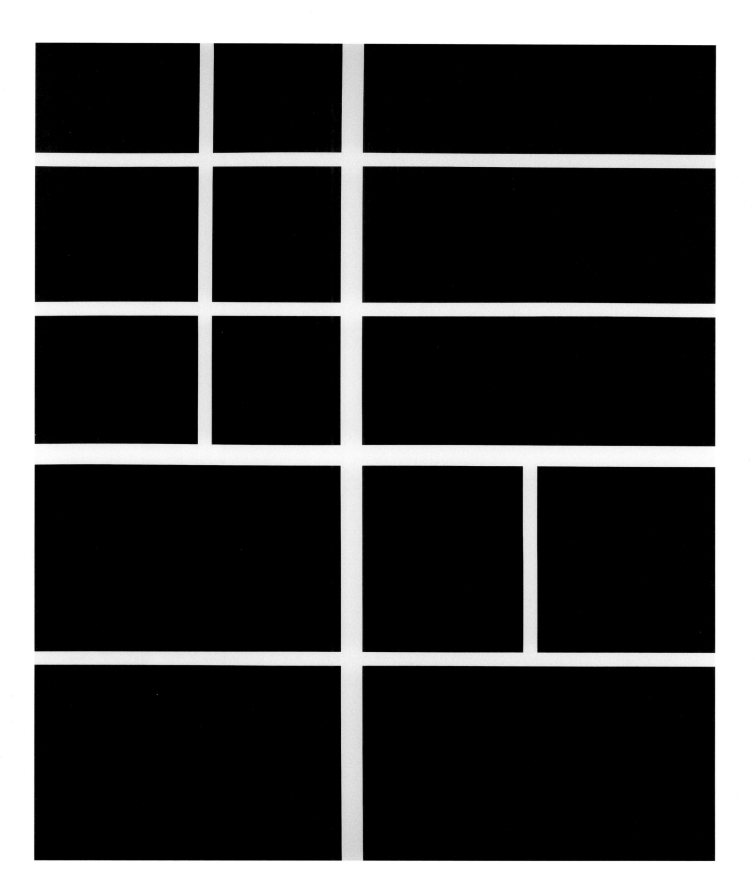

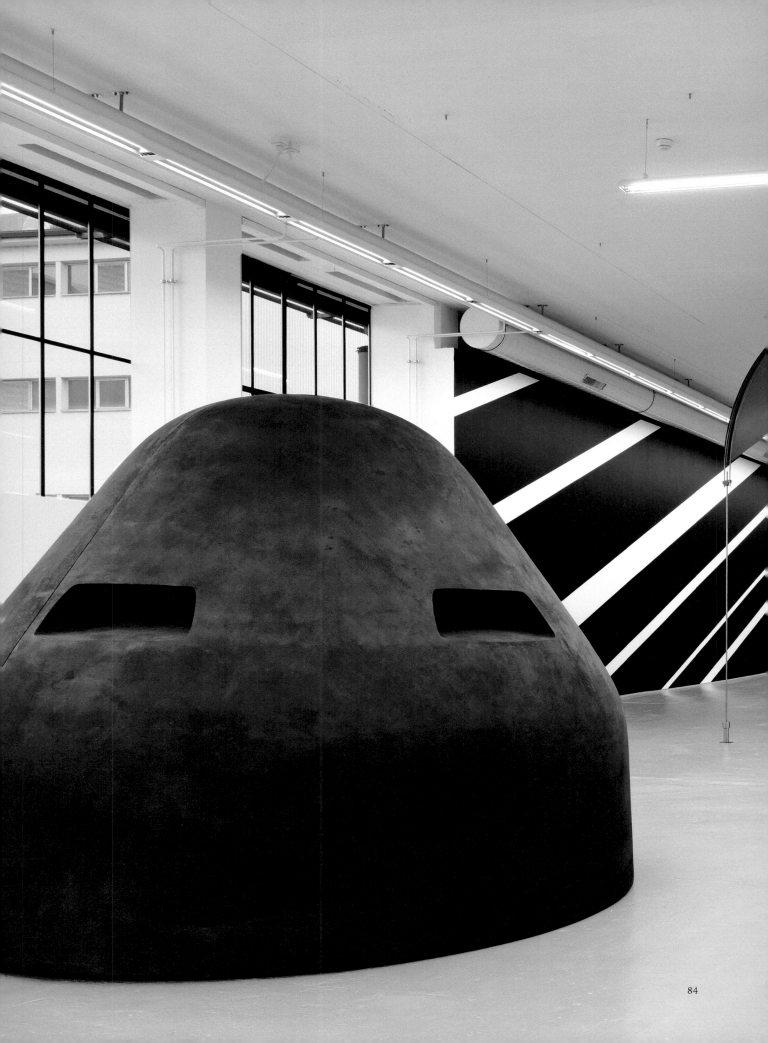

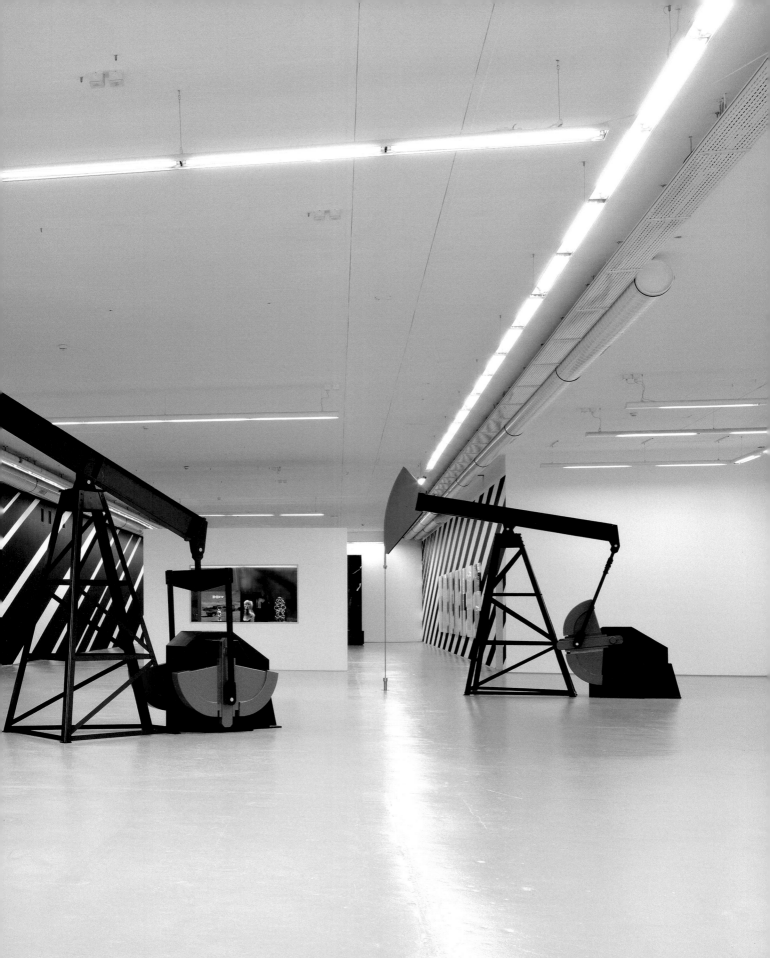

Exhibition view
migros museum für gegenwartskunst Zürich
2009

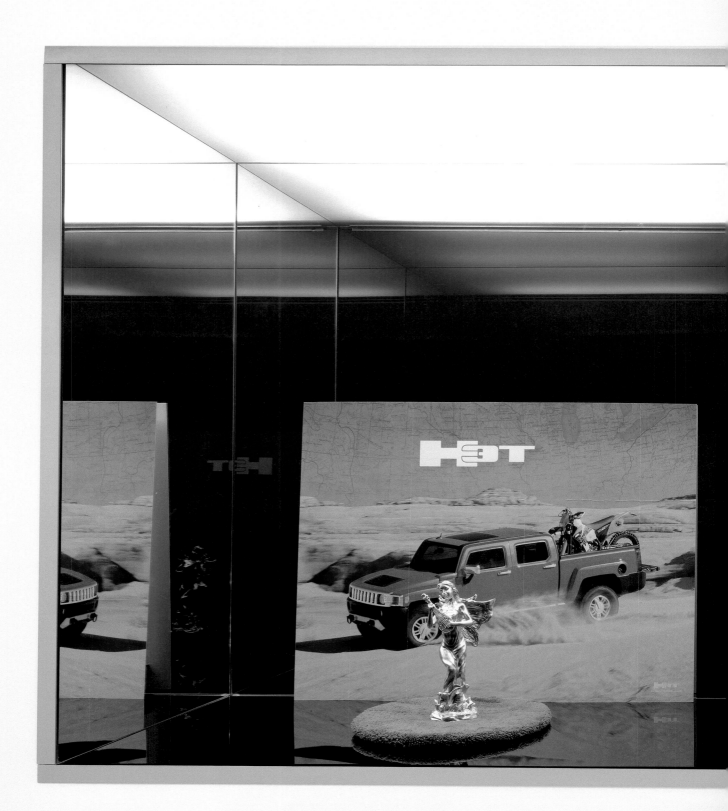

Fall of the Empire
2008

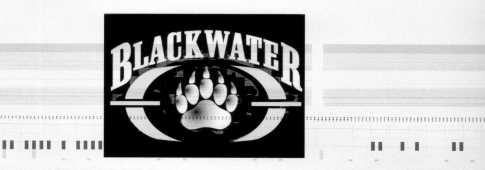

BLACKWATER

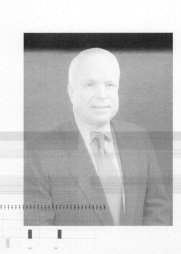

NO COUNTRY FOR OLD MEN

Blackwater, No Country for Old Men
2008

Untitled (Oil Rig No. 2)
2009

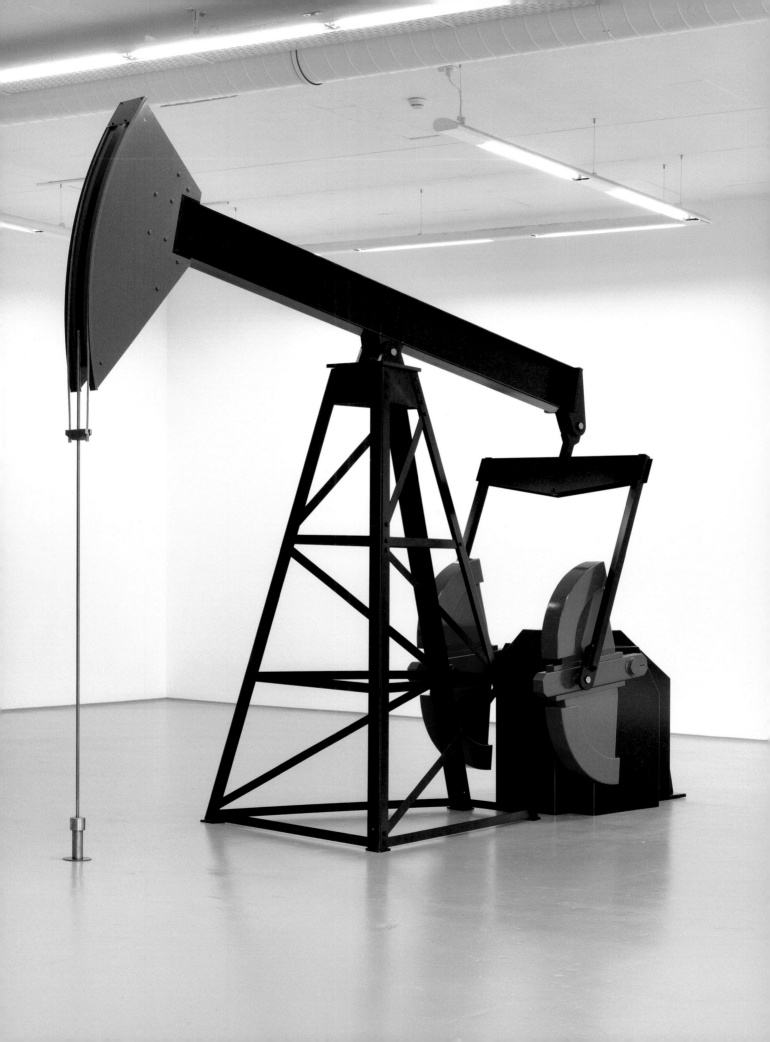

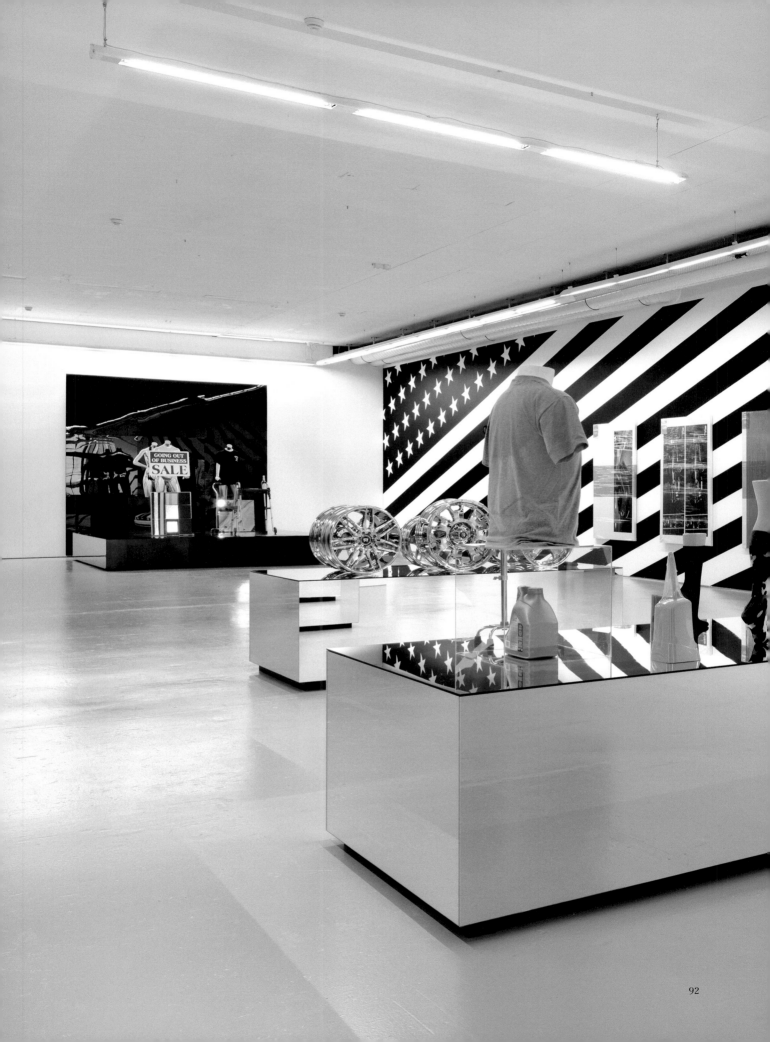

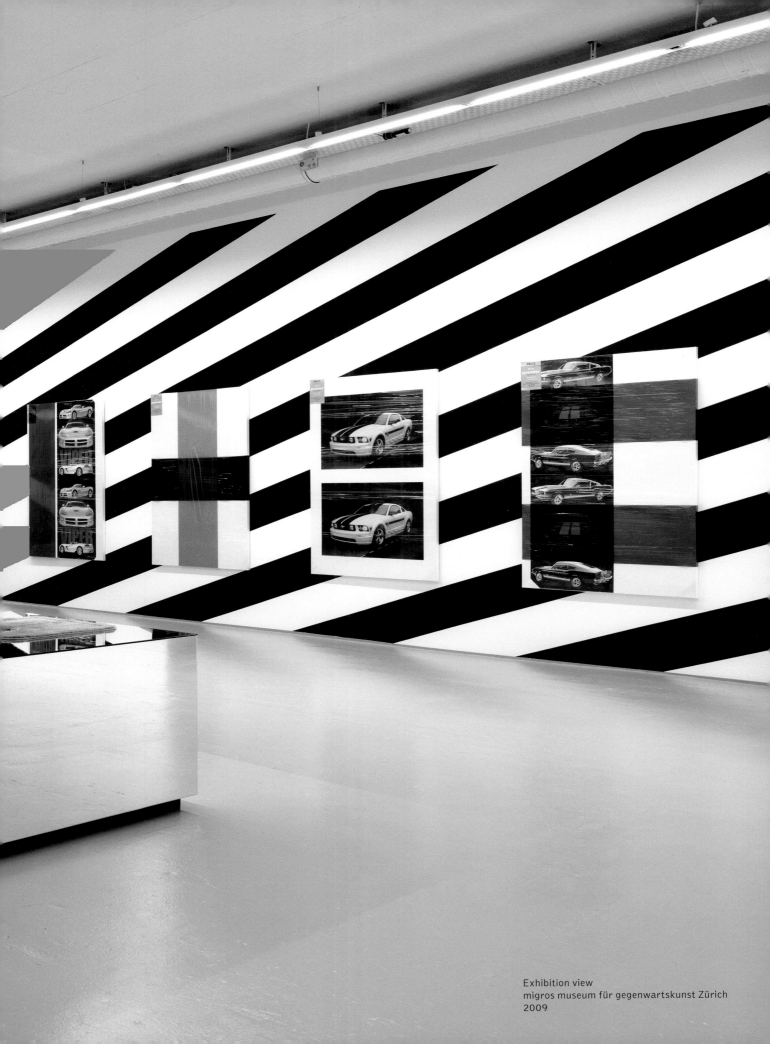

Exhibition view
migros museum für gegenwartskunst Zürich
2009

Thank a Vet
2008

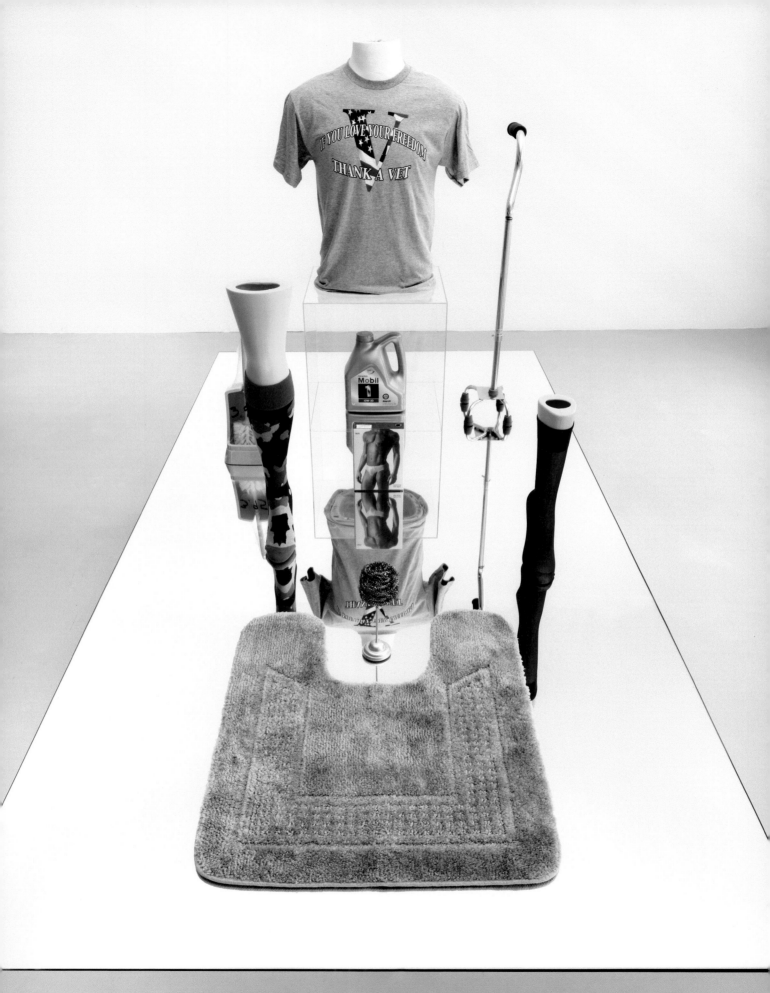

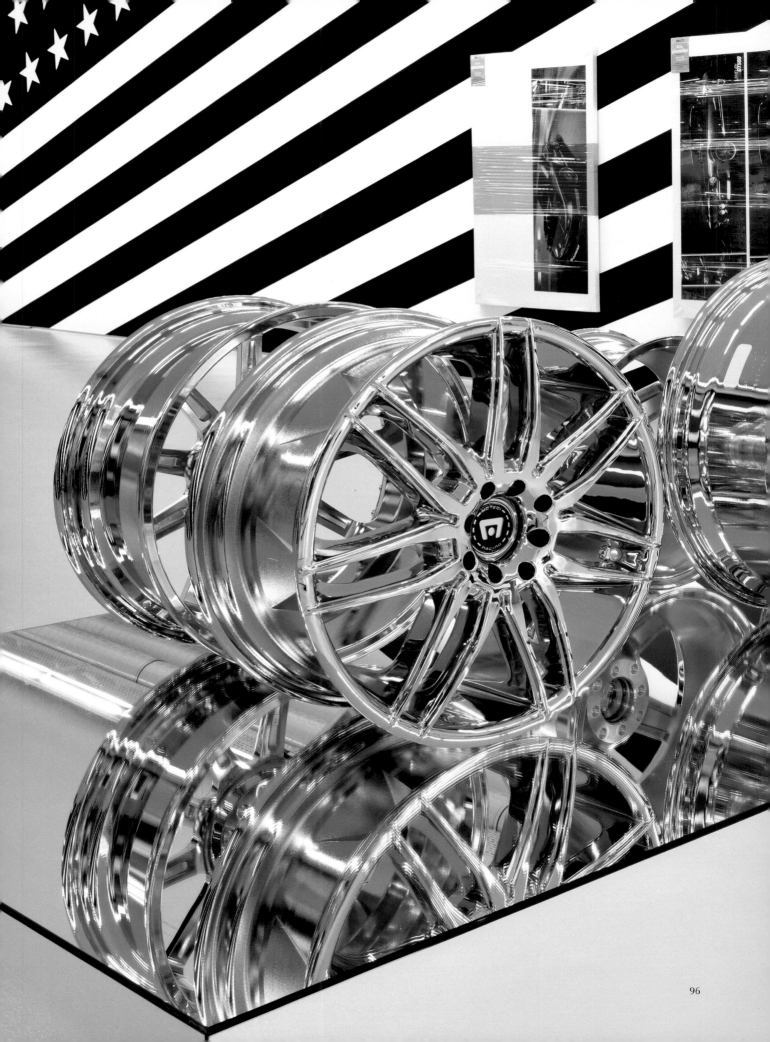

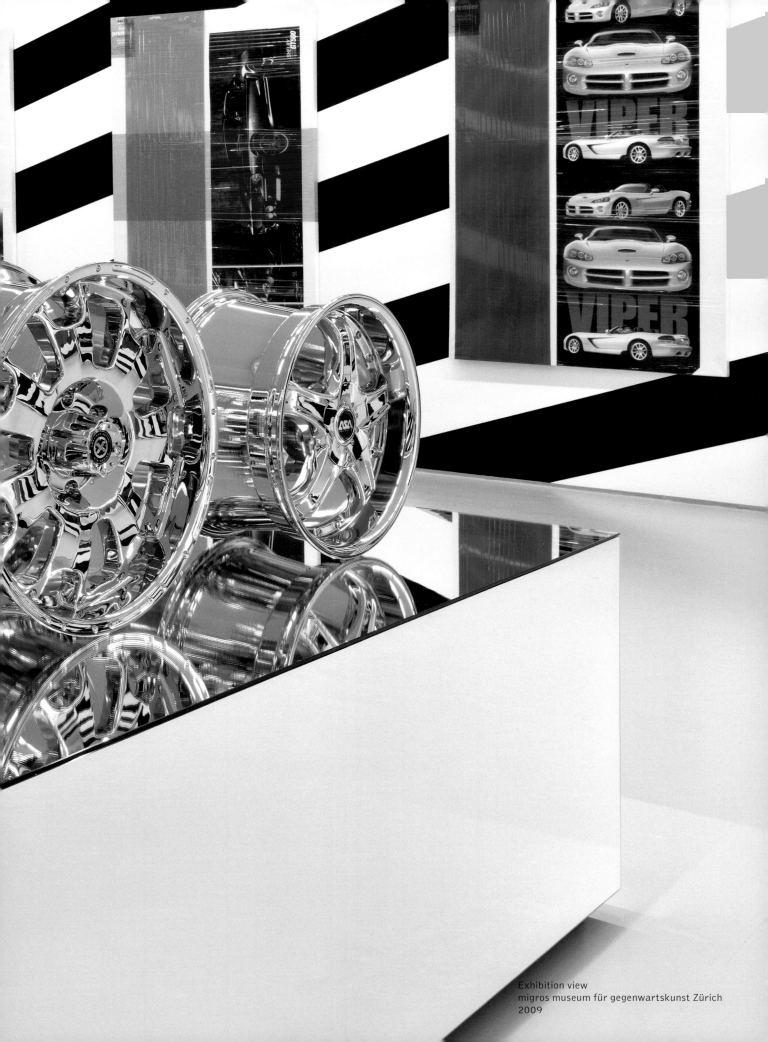

Exhibition view
migros museum für gegenwartskunst Zürich
2009

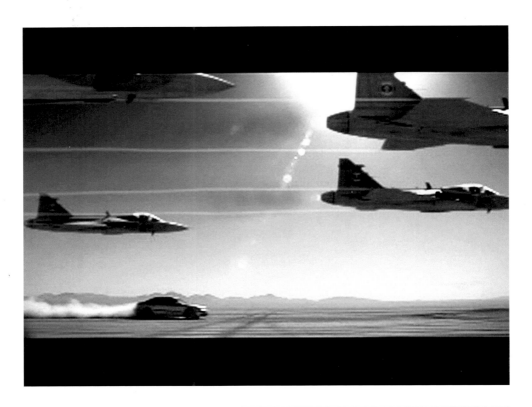

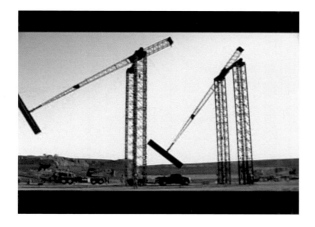
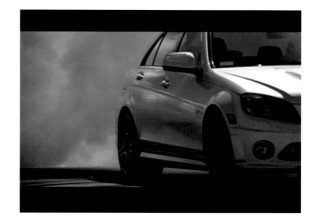

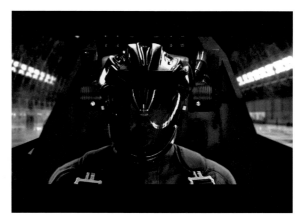
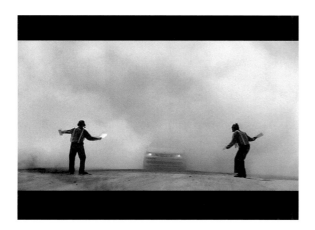
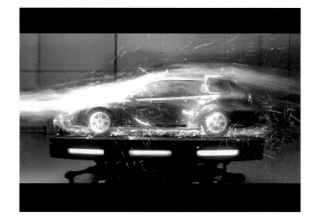

0% Down
2008

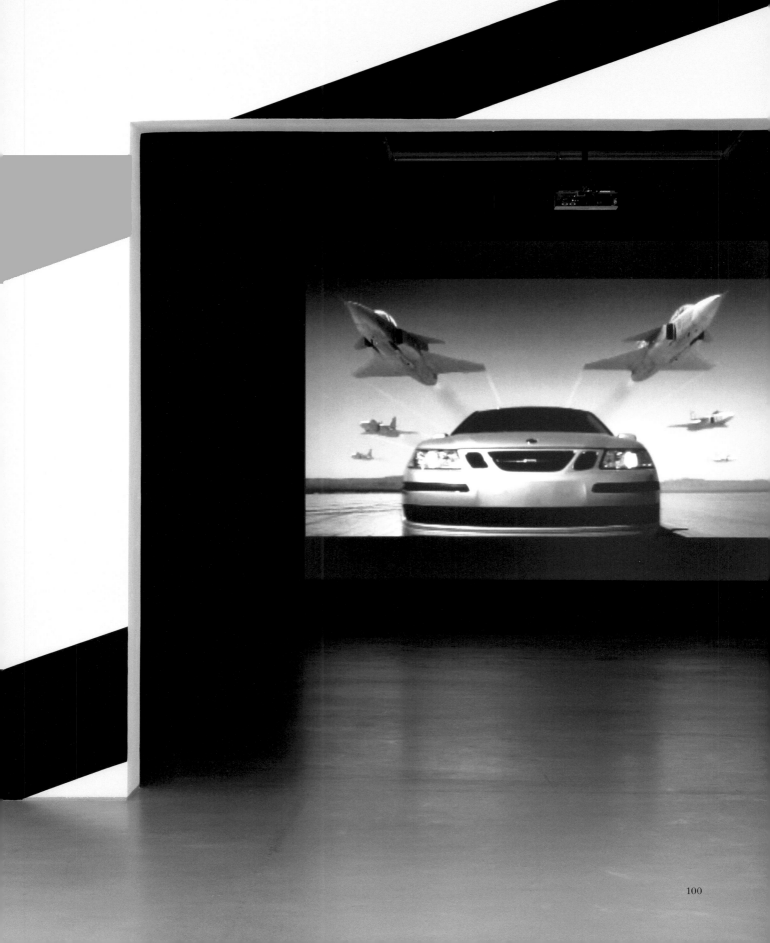

Exhibition view
Arndt & Partner, Berlin
2008

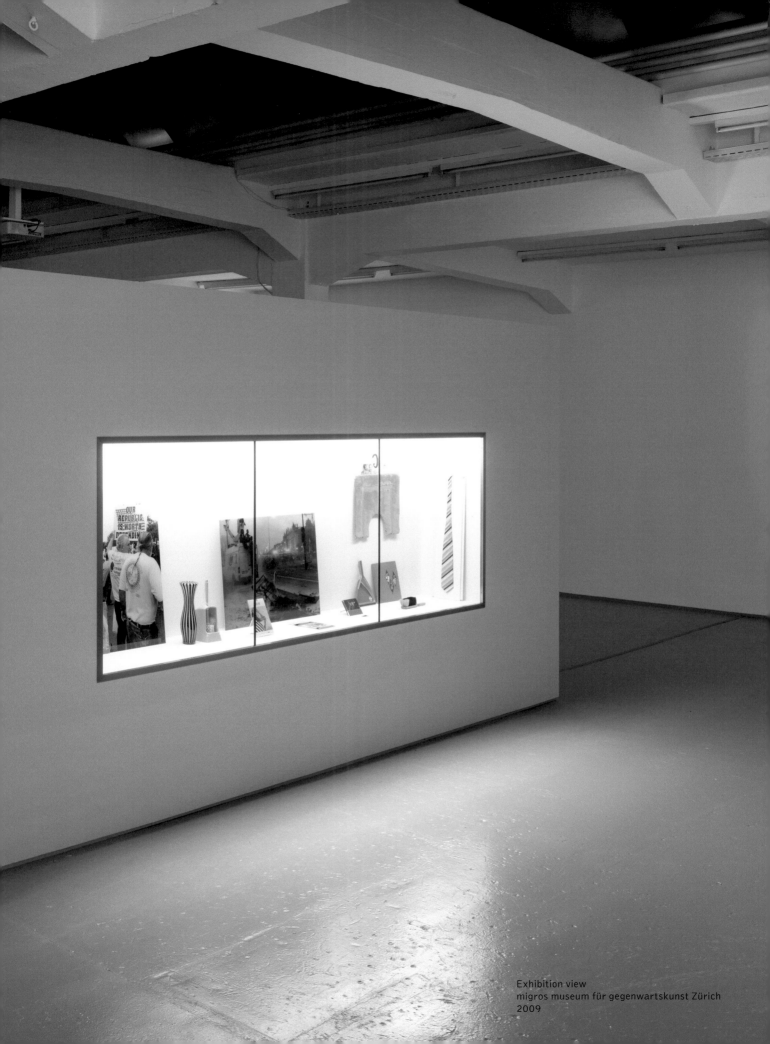

Exhibition view
migros museum für gegenwartskunst Zürich
2009

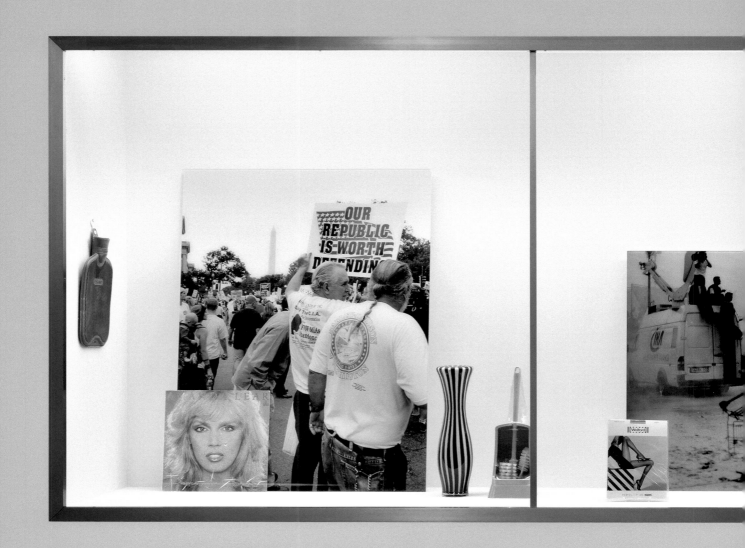

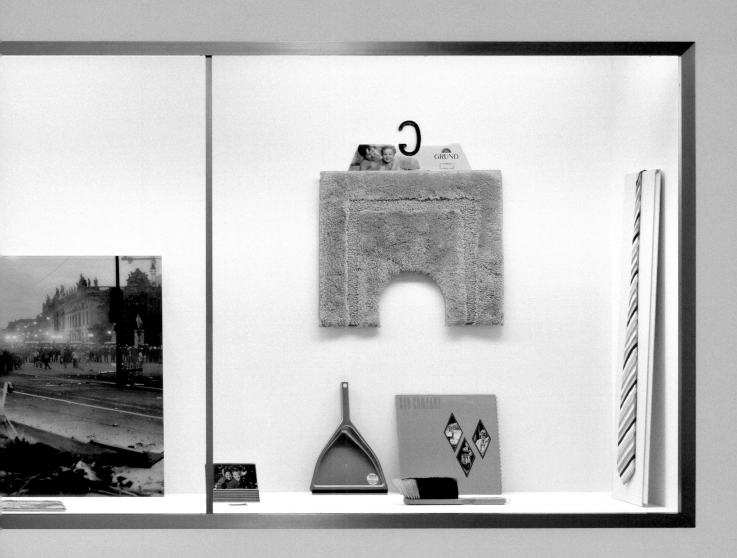

Verbraucherzentrale
2007

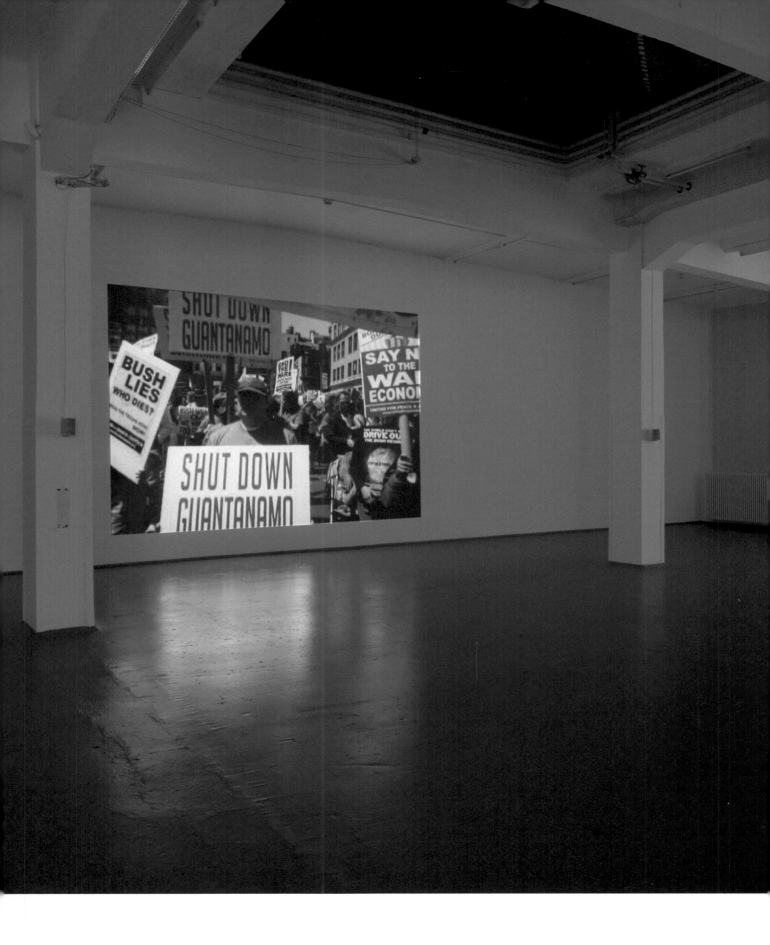

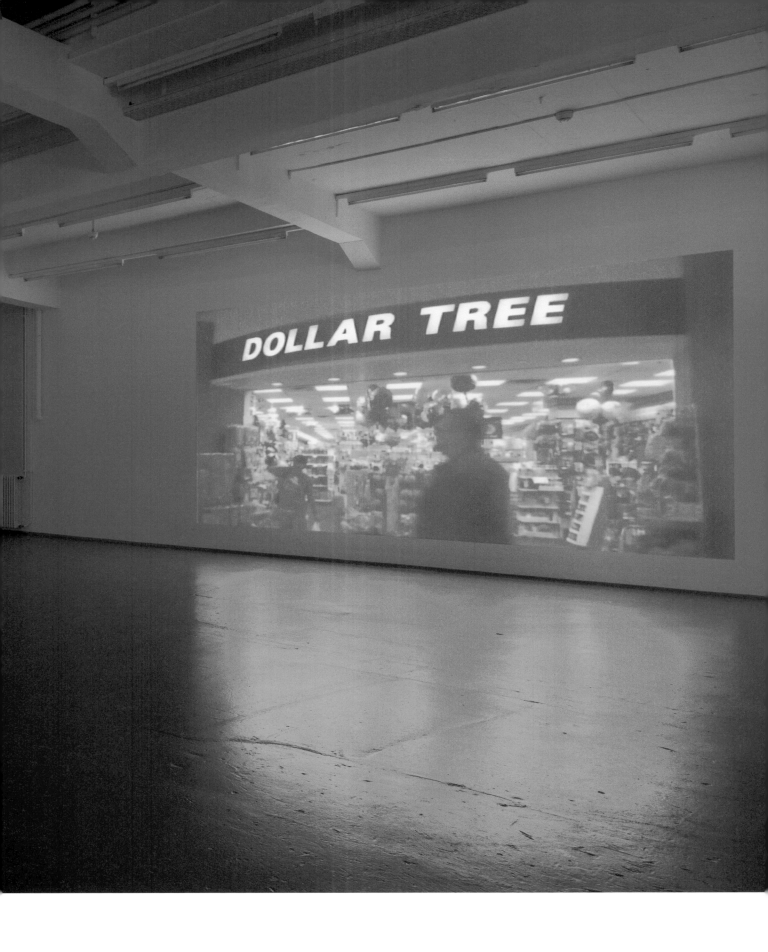

Exhibition view
migros museum für gegenwartskunst Zürich
2009

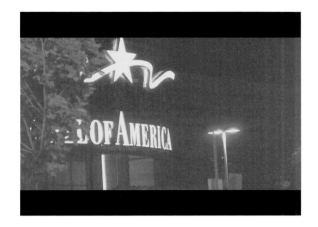

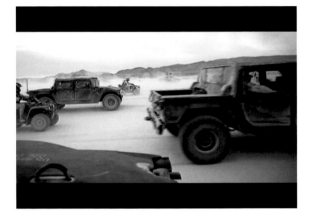

Mall of America
2009

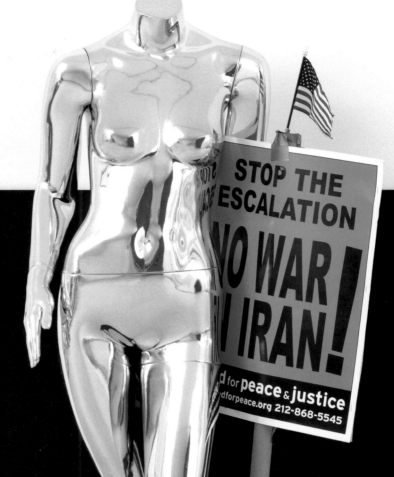

STOP THE
ESCALATION
NO WAR
IRAN!

d for **peace** & **justice**
dforpeace.org 212-868-5545

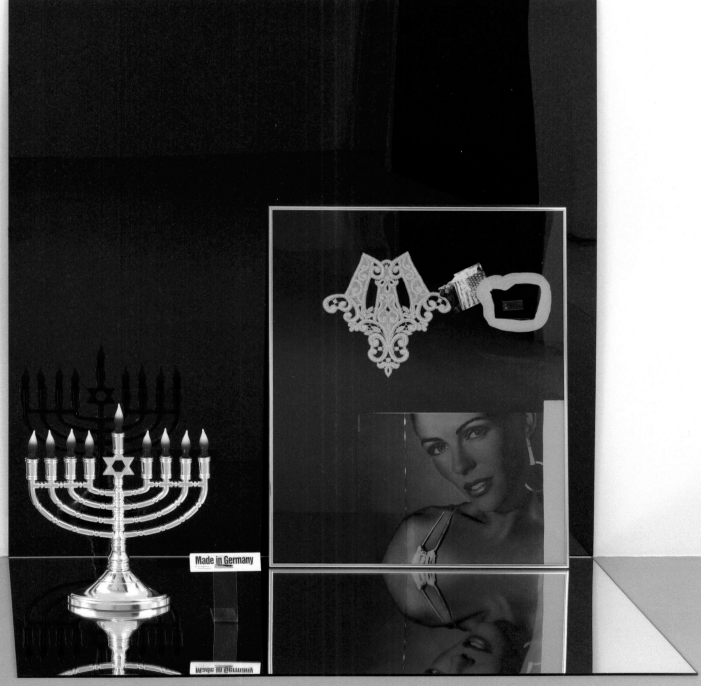

Save a Bundle
2007

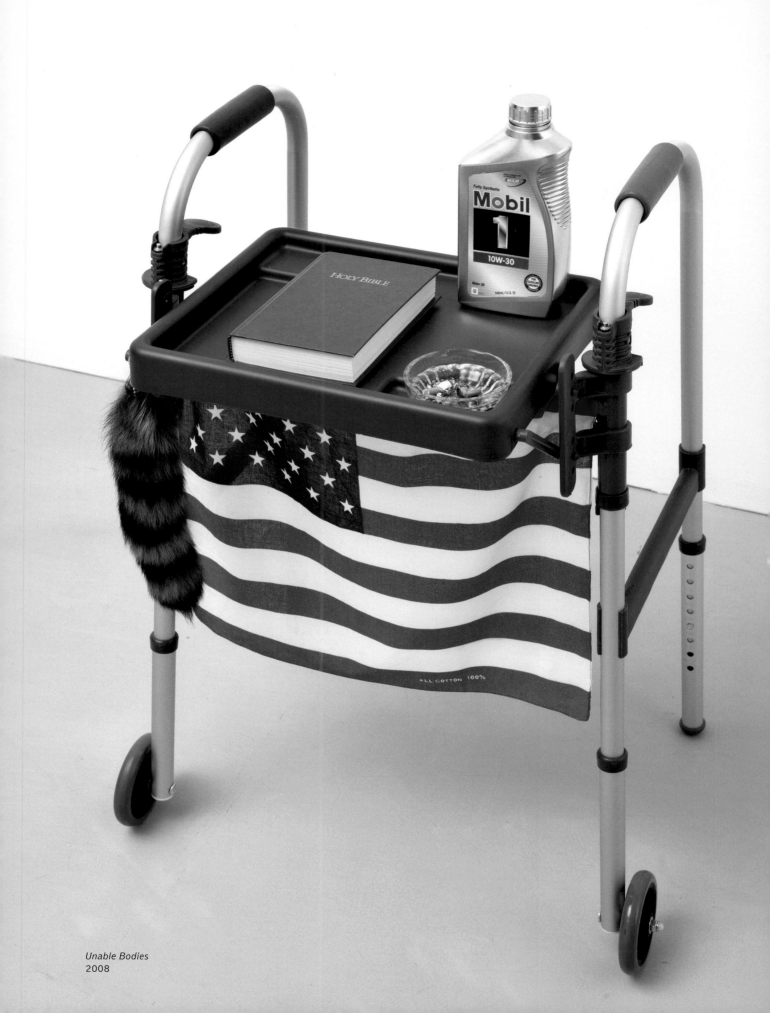

Unable Bodies
2008

Imprint

This book was published on the occasion of the exhibition *Josephine Meckseper* at the migros museum für gegenwartskunst Zürich, February 21st–May 3rd, 2009; Blaffer Gallery, the Art Museum of the University of Houston, September 12th–November 14th, 2009; Ausstellungshalle zeitgenössische Kunst Münster, October 24th–January 26th, 2010.

migros museum für gegenwartskunst Zürich

Director/Curator
Heike Munder

Assistant Curator
Raphael Gygax

Exhibitions Coordinator & Registrar
Judith Welter

Administrative Management
Catherine Reymond

Administration
Rosmarie Battaglia

Internship
Franz Krähenbühl

Technical Manager Exhibitions
Monika Schori

Technical Manager Collection
Roland Bösiger

Technical Support
Pius Aellig, Seline Baumgartner, Gabi Deutsch, Joël Frattini, Atheñe Galiciadis, Muriel Gutherz, Basil Kobert, Marcello Pirrone, Andri Zuppinger

Reception
Céline Beyeler, Irina Mach, Valentin Magaro, Christa Michel, Pablo Müller, Katharina Rippstein, Simone Schardt, Mareike Spalteholz

migros museum für gegenwartskunst
Limmatstrasse 270
CH–8005 Zürich
T +41 (0) 44 277 20 50
F +41 (0) 44 277 62 86
info@migrosmuseum.ch
www.migrosmuseum.ch

The migros museum für gegenwartskunst is an institution of the Migros Culture Percentage.
www.kulturprozent.ch

Blaffer Gallery, the Art Museum of the University of Houston

Director
Claudia Schmuckli

Cynthia Woods Mitchell Curatorial Fellow
Rachel Hooper

Registrar
Youngmin Chung

Contract Registrar
Monica Vidal

Exhibition Designer
Kelly Bennett

Museum Administrator
Karen Zicterman

Director of External Affairs
Susan Conaway

Assistant Director of External Affairs
Jeffrey Bowen

Curator of Education
Katherine Veneman

Assistant Curator of Education
Katy Lopez

Chief of Security
Measa Kuhlers

Blaffer Gallery, the Art Museum of the University of Houston
120 Fine Arts Building
USA–Houston, TX 77204-4018
T +1 713 743 9530
F +1 713 743 9525
www.blaffergallery.org

Ausstellungshalle zeitgenössische Kunst Münster

Director / Curator / Exhibitions Coordinator
Dr. Gail B. Kirkpatrick

Secretarial Office
Stefanie Möllers
Renate Wieland

Head of Exhibition Design
Christian Geißler

Assistants of Exhibition Design
Sebastian Bertuleit
Ingo Hürlimann

Public Relation
Verena Voigt

Education
Ute Bachmann

Ausstellungshalle
zeitgenössische Kunst Münster
Hafenweg 28
D–48155 Münster
T +49 (0) 251 674 4675
F +49 (0) 251 674 4685
kulturamt@stadt-muenster.de
www.muenster.de/stadt/ausstellungshalle

AUSSTELLUNGSHALLE
zeitgenössische Kunst **MÜNSTER**

PUBLICATION

Published by
migros museum für gegenwartskunst Zürich, Ausstellungshalle zeitgenössische Kunst Münster, Blaffer Gallery, the Art Museum of the University of Houston & JRP|Ringier

Editors
Rachel Hooper, Gail Kirkpatrick, Heike Munder

Editorial Coordination
Raphael Gygax, Heike Munder

Internship
Franz Krähenbühl

Translation from German
Ishbel Flett (Texts: Preface, Heike Munder)

Translation from English
Christian Quatmann (Texts: Rachel Hooper, Sylvère Lotringer)

Copy editing, German
Anna Brinkmann (Text: Heike Munder), Doris Senn (Text: Rachel Hooper, Sylvère Lotringer)

Proofreading, German
Doris Senn

Copy editing and Proofreading, English
Rowena Smith

Graphic Design
Marie Lusa

Lithography
Georg Sidler, Schwyz

Production
Odermatt AG, Dallenwil

Cover
Shelby GT500 (Black)
2008

All institutions would like to thank

Josephine Meckseper
Arianna Petrich
David Shull
Zachary Zahringer
Galerie Arndt & Partner, Berlin
Elizabeth Dee Gallery, New York
Galerie Reinhard Hauff, Stuttgart

migros museum für gegenwartskunst Zürich would like to thank additionally

Sammlung Dacic Hamburg
LBBW Kunstsammlung
Grace Family Collection, New York

Josephine Meckseper would like to thank

Arianna Petrich, New York
David Shull, New York
Zachary Zahringer, New York
John Mascaro, New York
Heike Munder, Zürich
Monika Schori and the entire migros museum technical design team, Zürich
Raphael Gygax, Zürich
Judith Welter, Zürich
Ruben Cista, Zürich
Kunstbetrieb, Basel
Reinhard Hauff, Stuttgart
Rachel Hooper, Houston
Gail Kirkpatrick, Münster

Ausstellungshalle zeitgenössische Kunst Münster would like to thank additionally

Der Ministerpräsident
des Landes Nordrhein-Westfalen

Freundeskreis der Ausstellungshalle
zeitgenössische Kunst Münster

LAARMANN
MÖBELSPEDITION

Blaffer Gallery, the Art Museum of the University of Houston

The exhibition and publication are made possible, in part, by The Cecil Amelia Blaffer von Furstenberg Endowment for Exhibitions and Programs, Houston Endowment, Inc., and the Consulate General of the Federal Republic of Germany.

JRP|Ringier
Letzigraben 134
CH—8047 Zürich
T +41 (0) 43 311 27 50
F +41 (0) 43 311 27 51
info@jrp-ringier.com
www.jrp-ringier.com

jrp|ringier

© 2009 the artist, the authors, the photographers, migros museum für gegenwartskunst Zürich, Ausstellungshalle zeitgenössische Kunst Münster, Blaffer Gallery, the Art Museum of the University of Houston & JRP|Ringier

Every effort has been made to contact copyright holders. Any copyright holders we have been unable to reach or to whom inaccurate acknowledgment has been made are invited to contact the migros museum für gegenwartskunst Zürich, Ausstellungshalle zeitgenössische Kunst Münster or Blaffer Gallery, the Art Museum of the University of Houston.

ISBN 978-3-03764-047-0

JRP|Ringier books are available internationally at selected bookstores and from the following distribution partners:

Switzerland
Buch 2000, AVA
Verlagsauslieferung AG
Centralweg 16
CH—8910 Affoltern a.A.
buch2000@ava.ch
www.ava.ch

Germany and Austria
Vice Versa Vertrieb
Immanuelkirchstrasse 12
D—10405 Berlin
info@vice-versa-vertrieb.de
www.vice-versa-vertrieb.de

France
Les presses du réel
35, rue Colson
F—21000 Dijon
info@lespressesdureel.com
www.lespressesdureel.com

United Kingdom and other European countries
Cornerhouse Publications
70 Oxford Street
UK—Manchester M1 5NH
publications@cornerhouse.org
www.cornerhouse.org/books

USA, Canada, Asia, and Australia
D.A.P. / Distributed Art Publishers
155 Sixth Avenue, 2nd Floor
USA—New York, NY 10013
dap@dapinc.com
www.artbook.com

For a list of our partner bookshops or for any general questions, please contact JRP|Ringier directly at info@jrp-ringier.com, or visit our homepage www.jrp-ringier.com for further information about our program.